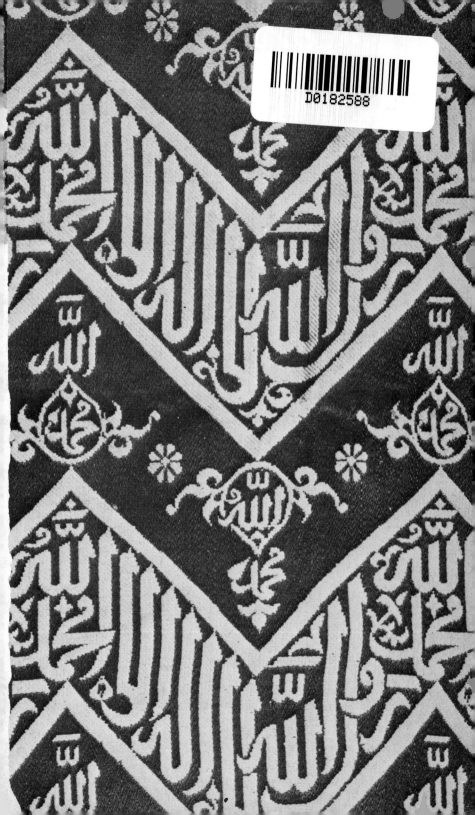

Treasures
of Islam

Philip Bamborough

Blandford Press
Poole · Dorset

£2

Philip Bamborough

First published in Great Britain
by **Blandford Press,** Link House, West Street, Poole, Dorset. BH15 1LL

ISBN 0 7137 8503 9 Cloth
ISBN 0 7137 8505 5 Paperback

First published MCMLXXVI

Copyright © Philip Bamborough MCMLXXVI

Dolphin Studio Production

Printed and bound in Great Britain
by Butler and Tanner, Frome, Somerset.

End Papers & Introductory Illustrations : *Tomb cover woven in silk. Arabic
inscription which repeats the names of Allah and Muhammad and the Islamic
prayer "There is no god save God, Muhammad is the Prophet of God."
Turkish 18th century.*

CONTENTS

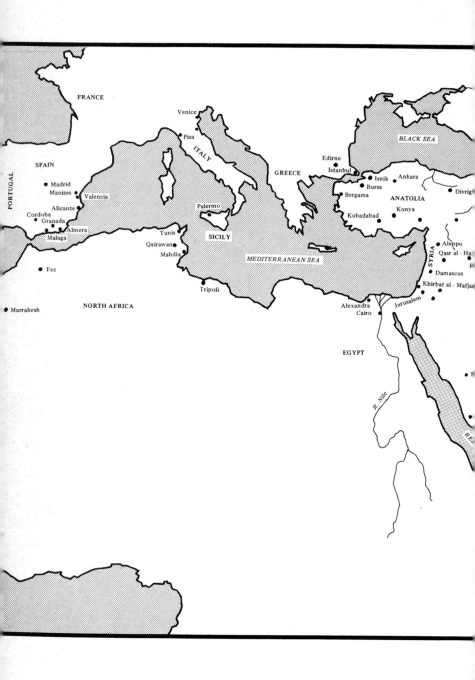

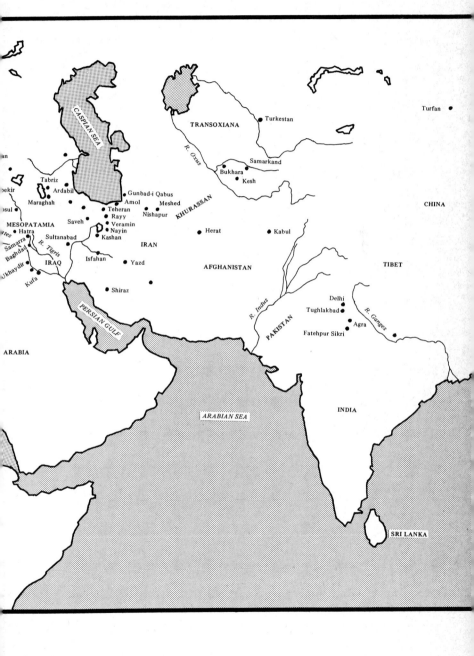

Turfan

CASPIAN SEA

TRANSOXIANA

Turkestan

R. Oxus

Samarkand

Bukhara

Kesh

CHINA

Tabriz

Ardabil

Gunbad-i Qabus

bekir

Amol Meshed

Maraghah

Teheran

Rayy

Nishapur

KHURASSAN

Herat Kabul

Saveh Veramin

osul

Nayin

MESOPATAMIA Hatra

ates

Sultanabad Kashan

IRAN

Samarra

R. Tigris

Baghdad

Isfahan Yazd

AFGHANISTAN

TIBET

IRAQ

Ukhaydir

Kufa

R. Indus

Delhi

Tughlakbad

R. Ganges

PERSIAN GULF

Shiraz

PAKISTAN

Agra

Fatehpur Sikri

ARABIA

ARABIAN SEA

INDIA

SRI LANKA

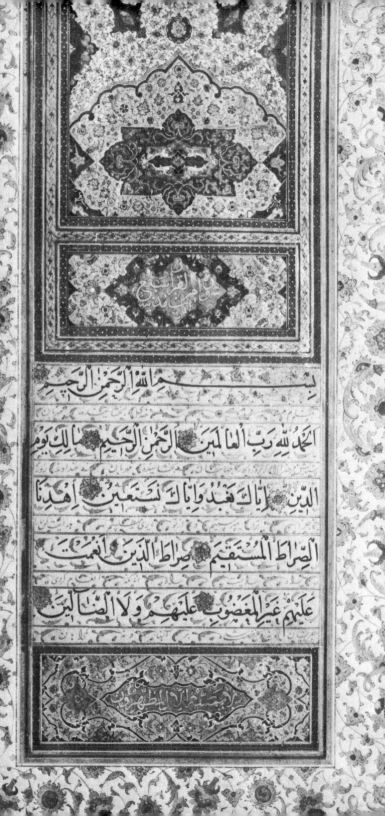

بِسْمِ اللّٰهِ الرَّحْمٰنِ الرَّحِيمِ

الْحَمْدُ لِلّٰهِ رَبِّ الْعَالَمِينَ الرَّحْمٰنِ الرَّحِيمِ مَالِكِ يَوْمِ
الدِّينِ إِيَّاكَ نَعْبُدُ وَإِيَّاكَ نَسْتَعِينُ اهْدِنَا
الصِّرَاطَ الْمُسْتَقِيمَ صِرَاطَ الَّذِينَ أَنْعَمْتَ
عَلَيْهِمْ غَيْرِ الْمَغْضُوبِ عَلَيْهِمْ وَلَا الضَّالِّينَ

1 THE TREASURE OF ISLAM

The huge red ball of the sun, rose slowly on the horizon gradually illuminating the silhouette of a desert city. A cloud of dust kicked up by a band of horsemen caught the sun's rays appearing as a whispy golden red cloud. The year was 622 A.D., the country Arabia, the horsemen, Muhammad and his band of followers leaving the city of Mecca. This relatively undramatic scene was in fact a momentous event in world history, for it was the Hijra, the flight of Muhammad from Mecca which marks the beginning of the first year of Islam. Muhammad, one time caravan leader and trader turned religious leader, was leading his followers to the city of Yathrib later to be called Medina, city of the Prophet.

The story of Islam, however starts twelve years earlier in Mecca, when Muhammad proclaimed the religion of Islam, ("I submit to the will of Allah"). His discontent with the religious situation in Mecca over the years had led to his ambition to restore the religion of Abraham, the worship of one God.

At that time the religion of Arabia was polytheistic with minority groups of Christians and Jews (later known as the followers of the book). Mecca was a prosperous city of merchants not a community given to religious observation and certainly not the best of populations to receive Muhammad's teaching. He attacked the people's adherence to idols, and their craving for wealth and luxury at the expense of the poor and urged them to worship the one God. Needless to say his actions in such a city did not endear him to the people, especially the wealthy and they turned on him. The persecution of Muhammad and his followers continued to grow until that fateful day in 622 when circumstances forced him to leave the city.

11

Muhammad believed that he was called upon by God to deliver God's words to the people. He received the messages from God over a period of years, and it is these words that were later written down and constitute the Koran, the Holy Book of Islam. Muslims believe that there is only one God, Allah, and Muhammad is his prophet. They do not deny that there were prophets at various times such as Abraham, Moses and Jesus, but believe that the prophet Muhammad is the last prophet and that his message in the Koran will remain unchanged for all time making any further prophets or books unnecessary. A Muslim believes that "Religion with Allah is Islam (surrender to His will)" *Koran, surat 3, Ali-i-imran, verse 19*. A Muslim observes his faith by adhering to the five principles of Islam: 1) The declaration of faith "La ilaha illallah Muhammad-ur-rasoolullah" meaning "There is no god but Allah and Muhammad is his Prophet". 2) The observance of obligatory prayers, five times a day. 3) The observance of *Zakat*, Islamic almsgiving fixed at two and a half per cent of one's annual wealth. 4) The observation of fast during the month Ramadan. 5) The performance of *Hajj*, or pilgrimage to Mecca at least once in a lifetime if possible. He must also adhere to the seven articles of faith which include; the belief in the oneness of Allah, and the existence of His angels, His books, His prophets, the day of Resurrection and the day of Judgement and lastly that the power for all action, whether good or bad, comes from Allah, but that people are responsible for their actions.

Islam, however is not simply a religion, it is a way of life, a curious mixture of religion, philosophy, social order and politics all rolled into one. The Koran dictates

how men should live their lives, and outlines a series of laws controlling what they may and may not do. Apart from the Koran, which is regarded as the word of God, there is also the apocryphal, Hadith (traditions) which records a collection of Muhammad's sayings, teachings, and judgements not included in the Koran. These two works were the basis for the eventual unification of the Middle and Near East, North Africa, Spain and India, under the banner of Islam.

To return to the Hijra. With the increasing persecution of the Muslims, Muhammad had been invited to Medina by its inhabitants who were symphathètic to his cause. Within a short time, the majority of the inhabitants of Medina had accepted Muhammad as their leader and become Muslims.

It is difficult to say whether the early raids (razzia) by the Muslims on Mecca and its trade caravans were in revenge for the persecution of the Muslims, an attempt to convert the inhabitants to Islam by force, or simply a way of obtaining enough money to sustain Muhammad and his followers, who presumably did not take up agriculture and could not therefore remain indefinitely as guests and burdens on their hosts. What is known is that to engage in the razzia was not considered unusual as it was an everday part of the life of the Arab nomads, almost a national sport. It had developed in a most sporting way, in which the main object was not to kill one's adversary but simply to capture or drive off as much booty such as camels, animals and even women as possible, with the minimum loss of life.

The effect of Muhammad's raids on Meccan trading caravans was so severe that a number of battles were fought, with the eventual result that Muhammad

captured Mecca. This was the beginning of the unification of Arabia under Islam, which was in a few years to spread to numerous neighbouring countries. Muhammad was soon the most powerful man in Arabia, which enabled him to dictate terms of non-aggression, or for the defeated, of surrender, terms which amounted to the total submission to Islam. The two basic requirements in such treaties were that they should perform public prayer and *Zakat*.

By the time Muhammad died on the 8th June, 632, approximately two thirds of the tribes of Arabia had become Muslims. After his death temporal power passed to his deputy Abu-Bakr who was appointed caliph ("deputy of the messenger of God"). After a brief reign of only two years Abu-Bakr was succeeded by Umar I. The succession of Umar I marked the beginning of the Arab expansion outwards from Arabia into Syria, Iraq, Persia, Lower Egypt and part of the North African coast. The phenomenal expansion of Islam under the Arabs is truly remarkable, for by the time of Umar's death in 644 all these lands had been conquered, and less than a century after the death of Muhammad, the banner of Islam extended from Spain to Central Asia.

Under Umar's successor, Uthman, a member of the Umayya tribe of Mecca, Arab expansion continued northwards from Iraq into Armenia and the Caucasus, westwards to Cyprus and the North African coast, and eastwards to Afghanistan, with raids even into Sind in India. Uthman was assassinated in 656 and replaced by Ali ibn-Abi-Talib, Muhammad's son in law and cousin. Thereafter followed a period of discontent within the conquered lands and what amounts almost to a civil war. Ali, however, was assassinated in January, 661. On

his death the caliphate returned to the house of Umayya who removed their capital from Medina to Damascus.

The Umayyad caliphate lasted from 661-750 A.D. Their downfall was caused largely by their disregard for the principles of Islam, under which all subjects were considered equal, by favouring their fellow Arabs. In 750 they were overthrown by Abu-l-'Abbas as-Saffah who established the Abbasid caliphate with its capital at Baghdad. Political unity, however, was at an end and many of the lands that had originally been conquered by the Arabs began to sieze independence though they still acknowledged the spiritual authority of the caliph.

Spain continued to be ruled under a local Umayyad dynasty, known as the caliphate of Al-Andalus, after which it split into a number of small kingdoms and states, under which the banner of Islam continued to fly until 1492. In 868, Egypt separated and established its own dynasty under Governor Ibn Tulun. Unrest in Iran and Central Asia led to the establishment in 874 of the Samanids, an indigenous dynasty, with their capital at Samarkand. Their dynasty ended in 999. Another indigenous Iranian power, the Buyids of South Iran, invaded Iraq and occupied Baghdad in 945. They were Shi'ites, a sect of Islam which believed that the caliph should be a descendant of the last orthodox caliph, Ali, the Prophet's son-in-law. However, in spite of this they paid lip service to the Abbasid caliph and allowed him to retain his position though only as their puppet.

During most of the 10th century there were actually three caliphs, the Abbasid, in Baghdad, the Umayyad of Cordoba, and the Fatimid caliph of Cairo. The Fatimids had established their caliphate in 969 which continued until it was overthrown by Saladin in 1171,

establishing the Ayyubid dynasty. The Ayyubids ruled Egypt and Syria until the mid 13th century. Meanwhile the Seljuk Turks, a people from Central Asia, overran Iran and Anatolia occupying Baghdad in 1055. They destroyed the Buyids placing the Abbasid caliph under their own "protection". The Seljuks of Iran ruled from 1037 to 1157 while the Seljuks of Anatolia ruled from 1077-1300. The Seljuks of Iran were destroyed and the Abbasid caliph assassinated with the invasion of the Mongols. They established a Mongol dynasty, the Ilkhanid, which ruled Iran until about 1349 when their rule disintegrated into a number of local governorships. After a further invasion from Central Asia under Timur, Iran was ruled by the Timurids until 1502, when they were replaced by an indigenous Iranian dynasty, the Safavids, who ruled until 1736.

In Turkey the Seljuks had been replaced in 1299 by the Ottoman Turks, whose marathon rule lasted for centuries until 1922. In the 16th century they began expanding both in neighbouring Islamic and non-Islamic countries alike. In 1517 they destroyed the Mamluk dynasty of Egypt and Syria, which had ruled since 1252. When the last Abbasid caliph was killed in 1258, the Mamluks had established a caliphate in Cairo with a relative of the Abbasid caliph in office. This continued until 1517 when the Ottoman Sultan assumed the title. In 1529 Vienna was besieged by Sulayman the Magnificent, and in 1540 Gibraltar was attacked.

Although Islamic incursions into India started as early as the 8th century it was not until the 13th century that Islamic rule was established after the conquest of Delhi by Muhammad of Ghor who appointed his slave Qutb al-Din Aybeck as Viceroy in Delhi. Aybeck was the first

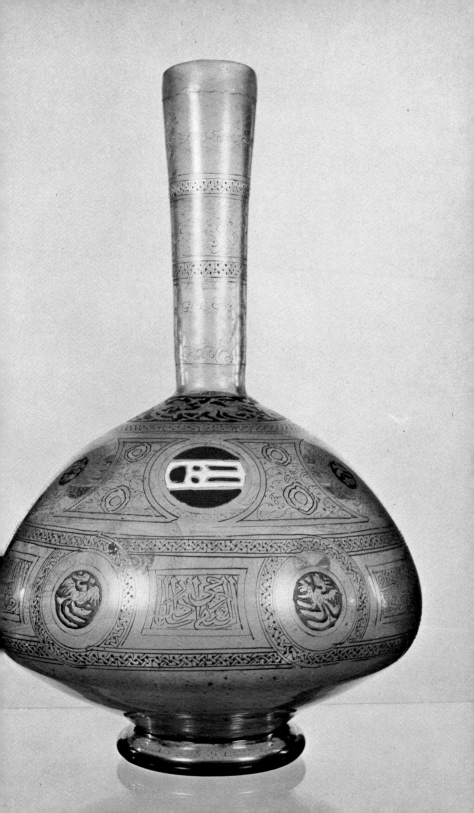

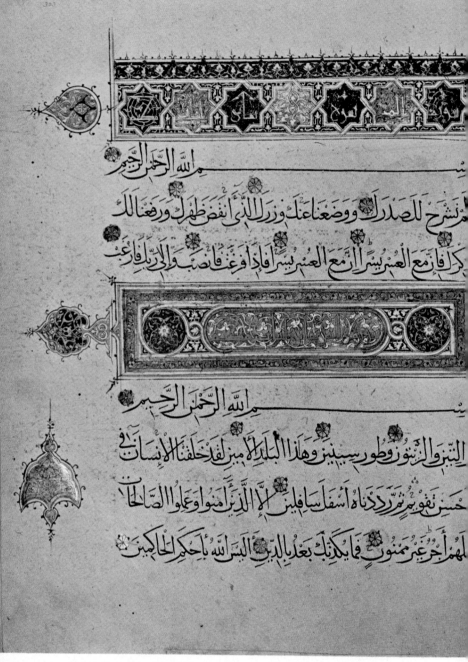

Above: Page from a Near Eastern Koran in Mamluk style. Written in Jalil, a style of Thuluth. 13th century.

Overleaf: Egyptian enamelled and gilded glass bottle. Cairo. 14th century.

of the Slave Kings who ruled at Delhi from 1206-1287 when the Sultanate fell into the hands of the Khaljids, after which the Tughlaks ruled from 1320-1412. A number of minor Islamic states were established in India but the Delhi Sultanate continued under the Sayyids (1414-1443) and the Lodis (1451-1519). In India the golden age of Islamic art, especially from the point of view of painting, took place under the Moghul empire, which was established in 1526 by Babar and which with the exception of a short period during the reign of his son, Humayan, continued until the beginning of the 19th century. The emperor Akbar (1556-1605) is generally regarded as the greatest of the Moghul emperors. During his reign elements of the native Hindu art were incorporated with that of Islam, to produce some of India's greatest art treasures.

As will be seen from the foregoing list of Islamic dynasties, Islamic art is made up from many ingredients and influences especially from the pre-Islamic traditions which existed before the Arab conquest. From the Arab art of the desert to the vibrant art of the Steppes of Central Asia; from the native Persian and Egyptian traditions to those of Byzantium and the vegetative native art of India - all contributed to the overall richness of the art of Islam. There is an identity to Islamic art which can be seen throughout the Islamic countries. An element of order and of the infinite pattern, of the abstract and the figurative. Islamic art is all powerful and all embracing. It is not a religious art and yet at the same time it is. Under Islam, artists were stimulated to excel themselves in all the arts, employing their mastery over the discipline of writing, beautifying the word of God; in buildings both religious and secular, in pottery,

metalwork, glass and textiles, and in the figurative miniature paintings, which, although not encouraged by Islam, were no doubt a direct result of Islamic culture. All these are, in addition to the religion itself - the real treasures of Islam.

Illustration at beginning of chapter: A page from an illuminated Koran by the scribe Muhammad Riza at Shirazi. The manuscript which is written in Naskhi and Nastaliq is from the library of Muhammad Shah Qasar. It dates to A.D. 1694. Below: the opening chapter of the Koran. 13th–14th century.

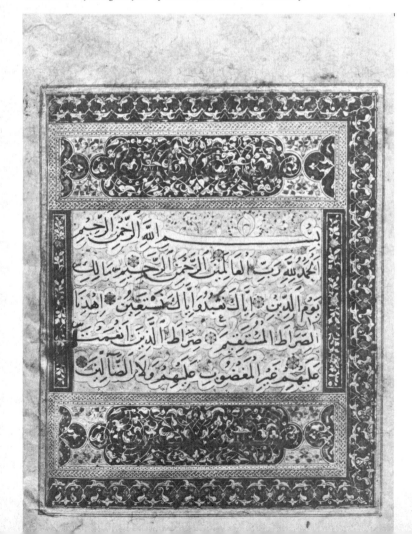

2 THE WORD OF GOD, THE HAND OF MAN

One of the visible links of Islam that can be seen throughout the Islamic world, in countries of different races and cultural backgrounds, is the Arabic script. The use of Arabic in the religion is an essential part of Islam, for it acts as a religious bond, drawing peoples together with a common religious language, in much the same way as Latin was used in the early Christian church. In fact, the parallel goes further. Both Latin and Arabic were the languages used by the original followers of Christianity and Islam respectively. The Koran teaches brotherhood in Islam with no discrimination between men of different races and colour. Arabic has helped to achieve this by providing a common platform and language of inter-communication. So successful has this been that over the last thirteen hundred years there have been more books written in Arabic in non-Arab countries than in Arab countries. The use of a common religious language has helped keep the forces of regionalism and nationalism at bay, which have many times threatened to break up the Islamic world. Arabic has given spiritual identity, a universal cosmopolitan entity and real meaning to Islam.

Arabic is the common language of both the Koran and the *Salat* (ritual prayers). The prescribed congregational *Salat*, as well as the personal *Salat,* is performed in Arabic as well as recitations from

A page of an 8th century Koran written on vellum. The last half of the page contains the Verse of Light.

the Koran. The prayers before, or after may, however, be said in the language of the country. Therefore, the religious ritual is both understood personally and universally throughout the world of Islam. Thus, travellers from any Islamic country can worship with complete familiarity in any country within the Islamic world. The idea of universal brotherhood runs throughout Islam. Thus, the five prescribed *Salats* link people together in prayer, symbolising the universality of the religion and brotherhood of man.

The Koran is the focal point of the religion. The Muslim believes that its beauty, comprehensive

and superb divinity, is not translatable, each letter and word being preserved, as it was revealed, and recited in every *Rakat* and in every *Salat*. Millions of non-Arabic people have memorised the entire Koran and recite it from cover to cover. Muslims also believe that the Koran is the last Holy Book (the Old Testament, Psalms and New Testament being others) and that it was revealed to the last of the Prophets, Muhammad for the universal guidance of mankind, only after the art of writing had developed sufficiently.

In fact, the reverse is the case, for until the seventh century A.D. there was little use for writing in the Arab world. The majority of knowledge, literature and poetry was handed down by word of mouth. This is interesting for the Arabs had developed a highly sophisticated language and were gifted poetically, almost entirely without the use of the written word. The tradition developed with each poet, having apprentices especially for the purpose of memorising, reciting, and eventually passing on the poet's works.

With the arrival of Islam everything changed. It was essential to record with precision every detail of the Koran revealed to the Prophet Muhammad. The only way to do this was through writing. Thus, an art which had

Page from the Koran, Surah XXVI, verses 126–136, written on vellum in a script derived from Kufic. Arabic, 10th century.

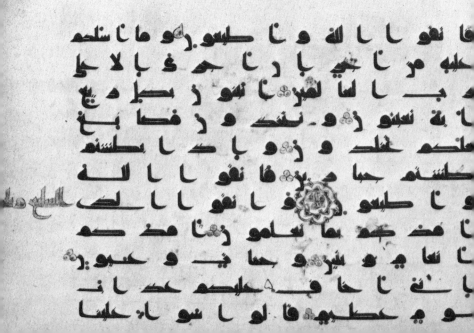

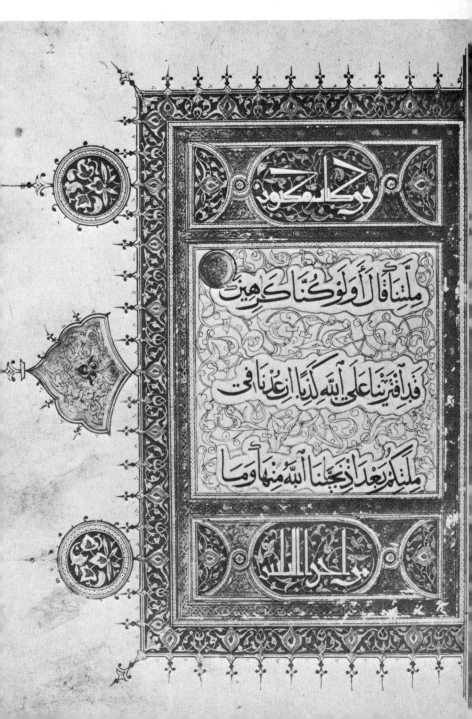

Illuminated page from the Koran of the 2nd page of Juz' IX. Egypt, 14th century.

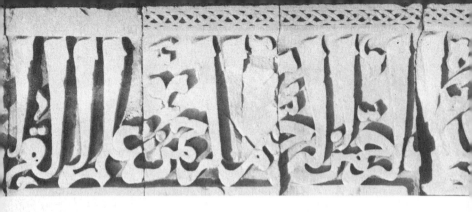

Relief inscription in Kufic on the screen of Altamish at the ruins of the Quwwat ul-Islam Mosque, Delhi in India.

been given little importance was suddenly called upon to record and express the word of Allah. Such was the importance of the need to record, that within a hundred years of Muhammad's death, the Arabic script had developed to the level of a high art and spread to all corners of the expanding world of Islam.

The Koran is the link between the Arabic script and the Islamic world. It is regarded not as the written account of the Prophet's teachings, but as the very word of Allah. Thus the Koran differs from the New Testament, for the New Testament is a record of Christ's activities on earth, while the Koran is the word of God. The Koran, when written, assumes an importance parallel to that of an icon in other faiths. Thus, the writing used to record the words of the Divinity, by its very use assumes a position of great importance in the religion. With this stimulus, it became necessary to use the finest calligraphy that could be achieved using the primitive script. The word of God together with the hand of man combined to create perhaps the greatest examples of calligraphy in the history of mankind. The ex-

plosive artistic energy created by this new partnership flowed throughout the world of Islam.

At an early date calligraphy became more than a mechanical literary record, it became a visual art of the highest order. The Arabs, who had never expressed themselves artistically through pictorial representation, found an outlet for their artistic genius in calligraphy. There is little doubt that calligraphy is the greatest artistic achievement of Islamic culture. In fact its importance to Islam and Islamic art is paramount. Without understanding the unique importance and significance of calligraphy to Islam, Islamic art cannot properly be understood, let alone appreciated.

In addition to its use in books and in the decoration of some objects d'art, calligraphy was used both religiously and artistically on the interiors and exteriors of buildings, especially mosques, to the total exclusion of pictorial representation, for the use of beautifully written verses from the Koran made it unnecessary. It is therefore, more likely that artistic tradition and development has more to do with the absence of pictorial forms on Islamic

architecture and religious manuscripts, than Koranic law. Calligraphy then, is one of the true treasures of Islam.

The copying of the Koran was considered of great spiritual benefit, both to the calligrapher and to his patron, thus many of the great Arab calligraphers devoted their entire time to making copies of the sacred book. Due to the basic simplicity of the linear forms, there are more styles of writing Arabic than any other script. Although numerous, they can be divided into two basic types, the formal scripts, generally called "Kufic" used mainly for official and formal documents, and the cursive scripts of which there are three main types Naskhi, Nastaliq and Thuluth. An idea of the multiplicity of the scripts may be had by the fact that one Persian calligrapher was accredited with being able to write in seventy different scripts. The variations of Arabic script are both regional and chronological. The oldest is Kufic, so called after the town Kufah, near Baghdad, in which it may have been first used. Korans are written in this script. Kufic is bold, angular and majestic and was ideally suited for the oblong format of the early books. It is suited to monumental use and on architecture and is still used for inscriptions on stone.

Korans were made both for personal and communal use. The latter were generally very large, with pages sometimes measuring several feet across when opened

Glazed Ceramic tile, with a raised Naskhi inscription in blue. From the Mosque at Nataniz, Persian, 13/14th century.

flat. Korans of the 7th - 10th centuries were of horizontal form, a shape to which the early Kufic was highly suited. Its majestic and monumental quality has an austere air, somewhat befitting the religious text. Kufic is easy to recognise, in that it is angular, using large horizontal and short vertical lines, and the curve. The horizontal lines were often doubled in parallel, accentuating both the horizontal format of the script and the book. In its primitive form there are no diacritical marks, which often caused inaccurate interpretations, especially among non-Arabic peoples. Quite often, due to its elongated horizontal nature, a single compound word would occupy a whole line of a Koran.

There are a number of forms and variations of Kufic, some extremely elaborate and decorative. Floriated and foliated Kufic are examples of the latter. Sometimes mistaken for each other, they are in fact quite distinct. In foliated Kufic the verticals terminate in half palmettes, while the final letter of each word is elongated vertically ending in a palmette or branching into leaves. The foliation was sometimes further emphasised by surrounding the script with an interlaced pattern of leaves, tendrils and other vegetation. It is in this form that it is often confused with floriated Kufic, which although similar to foliated Kufic, has the leaves, tendrils and palmettes sprouting from the letters themselves. Floriated Kufic is thought to have originated in Egypt, sometime at the end of the 8th century.

A popular adaptation of Kufic for decorative purposes, was plaited Kufic. In this form the vertical letters were plaited into intricate knots. Plaited Kufic was extensively used in architectural decoration, as well as for textiles, carpets etc., and sometimes for the frontispieces of Korans. Plaited Kufic, unlike foliated or floriated Kufic, remains legible even in the most complicated plaits.

Another variation is bent Kufic, from which the Moorish Maghribi script developed. Some of these decorative scripts are often so manipulated and exaggerated for decorative purposes that they are impossible to read. However, the majority of such inscriptions are verses from the Koran, used to decorate the interiors of mosques and other religious buildings and as such their legibility is unimportant. They were purely symbolic of the divinity - the word of God.

Local variations of Kufic developed in other parts of the Islamic world including Egypt (as mentioned above) Iran and the Maghreb. In Iran the local forms of Kufic - "eastern" Kufic and Qarmathian continued to be used for Korans until about the 13th century, several centuries after it had been superceded by Naskhi in other areas.

Above: A Koran from Nigeria which illustrates a Mid-West-African development of the arabesque. Late 19th century/early 20th century.

Below: Pages from an Indian Koran written in 1573 for the Sultan of Lahore. The script is Naskhi except for the three dividing bands of Thuluth.

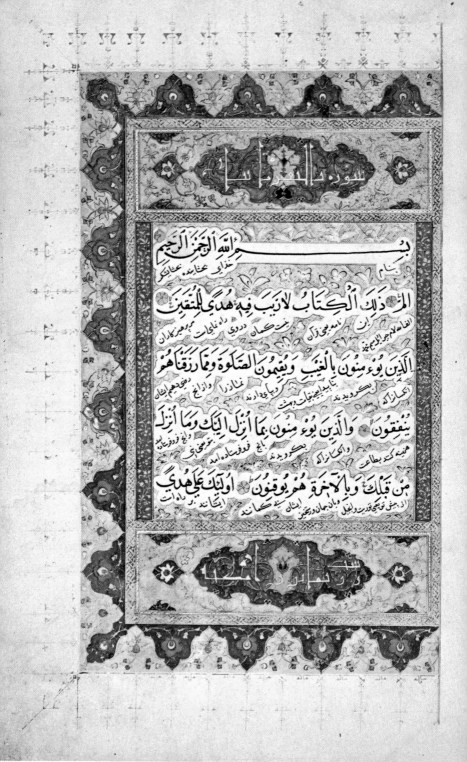

A Turkish Koran written for Sultan Mehmed Fatih. The head and foot bands are
in Kufic, while the Arabic verses are written in Naskhi with Persian interliniar

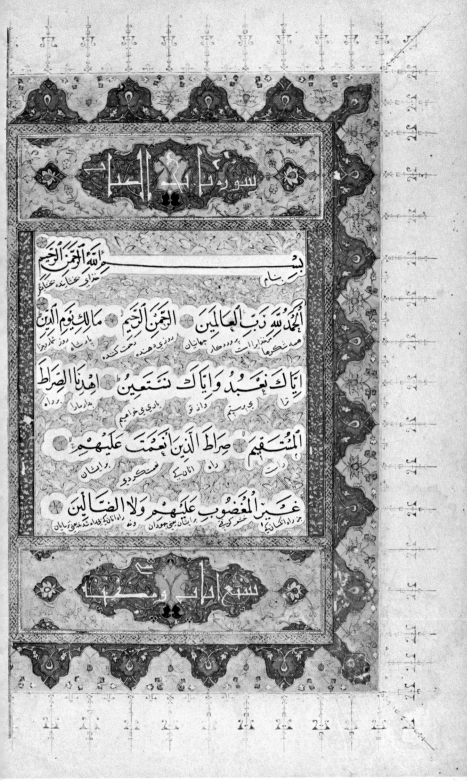

translation. Gold flowers separate the verses. 3rd quarter of the 15th century.

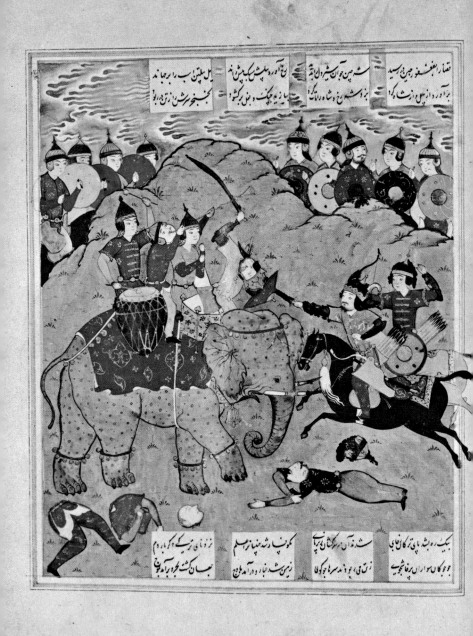

A page from the Shahnama with four neat columns of Nastaliq script. Persian, dated 1583.

Some of the finest examples of Kufic are found not in books but on pottery, in particular the white stoneware of the Iranian Samanid dynasty, from Samarkand and Nishapur. Although the Samanids were anti-Arabic and somewhat nationalistic, they had great reverence for the script which was identified with the divine nature of the Koran. Some early plates are inscribed in simple Kufic while later the inscriptions became more ornate, with the addition of foliated decoration. In reverence to the Koran, inscriptions on common and fragile vessels were non-Koranic.

In North Africa and Iberia, the Maghreb, which had been somewhat isolated from the rest of the Islamic world since about the 8th century, the later scripts and developments had little effect, although both Naskhi and Thuluth were used at times. However Kufic was modified and retained and is still in use today. This "western" script is known as Maghribi. It is, however, noticeably different from Kufic in its use of sweeping arcs beneath the line. The letters, which in Kufic would extend below the line are in Maghribi extended downwards and then upwards in a deep curve. Before the development of Maghribi, Kufic was used in both its simple and ornate forms.

In Andalusia, after the Arab conquest in 711 A.D. the script was not purely identified with Islam, but with a culture superior

Ornamented title-page of a Koran in seven volumes, written and illuminated for Rukn ad-Din Baibars, afterwards Sultan Baibars II. Egypt A.D. 1304.

to the Christian Latin culture which it had surpassed and replaced. This recognition of the superiority of the Arab culture of the period by the Andalusians was followed by the adoption of Arab dress, language and script, even by those who were not converted to the Islamic faith. In tropical West Africa, a local form of Maghribi was developed. There, in the Islamic communities of Nigeria, and as far north as Mali and Senegal, Arabic culture has been grafted onto the indigenous with little difficulty.

By the 11th century, in addition to Kufic there were eight basic scripts in use. These were

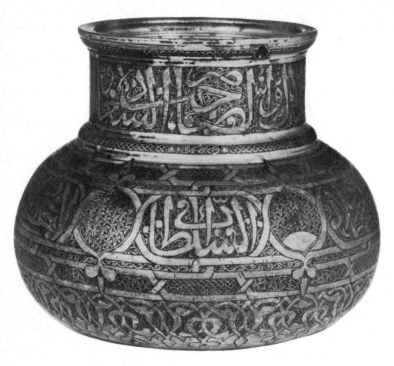

Some of the finest examples of calligraphy is to be found on ceramic and metal objects such as this superb bronze water pot, of the Mamluk period of Egypt.

Thuluth, Rihan, Tauqi, Muhaqqaq Riqa and Naskhi. These cursive scripts developed from the need to write with greater speed and with greater accuracy. Both of these criteria were fulfilled by the Naskhi scripts which employed both diacritical points and vowel sounds, making it easily understood.

The names of two famous calligraphers are associated with the development of Naskhi, Ibn Muqla (died 939) a minister of the Abbasid Caliph of Baghdad, and Ibn Al-Bawwab (died 1022) a house painter. The former is credited with systemising what

was at that time a script with no rules, relating each letter with the tall vertical "aliph", while the latter with perfecting Naskhi, which is probably the most evenly balanced of all scripts. Today it is the principal script used for printing.

In Mamluk Egypt the dignified hieratic Thuluth script was preferred, where it was used for both religious and official calligraphy. The finest examples of Thuluth calligraphy are found on the superb glass vessels and mosque lamps as well as on metalwork, - all treasures of the Mamluk artist. In Mamluk Egypt the figurative

decoration so popular on the metalwork of 12th and 13th century Iran, Syria and Mesopotamia is replaced by superb and sometimes grandiose calligraphic inscriptions. Unlike the reserve of the Samanids inscriptions on the glass mosque lamps were both dedicatory and Koranic. Many bore a verse from the Chapter of Light.

In Iran, a particularly unusual form of ornate calligraphy developed in which the strokes of the Naskhi script were ornamented with animals, birds and human forms. It reached its most effec-

Illuminated page of a 16th century Morrocan Koran written in Maghribi. The Chapter of Victory.

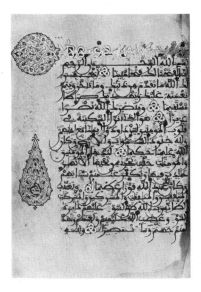

tive form on metalwork of the 12th to 13th centuries.

Another unusual development also occurred in Iran, that of the Kufic meander. This is a marriage of Kufic calligraphy and geometric order. The inscription is organized on a grid of identical squares, the resulting layout being capable of an intricate repetition of interlacing patterns.

After the invasion of Iran by the Mongols and later by Timur in the 14th century, two new styles of writing developed, displacing Naskhi, mainly for writing Persian. They were Ta'liq and Nastaliq. Although Ta'liq was known before the 14th century, it was not until the 14th century that it became popular. It differs from the Naskhi and other earlier scripts in that it used broad, sometimes exaggerated horizontals with short verticals, written with a thick obliquely cut pen. Nastaliq, invented by the Tabriz calligrapher Mir Ali, is much lighter and more airy than Ta'liq, tending to float among its diacritical marks. The beginning of the words tend to rise upwards.

The Timurid and Safavid rulers patronised both calligraphy and its associated art, painting, and calligraphic decoration on the ceramic tiled interiors of mosques rose to magnificent heights. In the 17th century another elaborate, somewhat personal script called Shikastah came into use. This romantic hand, blurred the beginnings and endings of words and

در بستان مرغ صفت رنگ وزن زاهد وکشتن مرغ از برای معشوق پا

رسیدن زاهد وخجل ماندن زن زاهد ازرا بدسته پنجاه ه دوم

چون مرغ آسمان کرد آفتاب در آشیانه مغرب رفت و باز سیمین ماه از هوا مشرق

پرواز کرد دخته بطلب رخصت بر طوطی رفت طوطی را دید سر در تا مل فرود کرده

وتفکر وار نشسته پریدی مرغ آزاد کر توازافواج شوق بی علمی و از تلاطم امواج

عشق من بیخبری تو متأمل برای چه باشی و تفکر سبب چه نشینی قطعه

بخشی غم غریب عشاق اوست ٭ ٭ ٭ ٭ ٭ هرکه اونیست در جهان عاشق

فارغ البال را در چه کذر ٭ ٭ ٭ ٭ ٭ غم و اندیشه را بر وچه کذر

Left Indian Moghul painting of a girl having a conversation with a parrot. The script is Nastaliq C. 1570—80.

Persian, ceramic jug, decorated with a superb inscription in Kufic characters carved through a layer of black slip. 13th century.

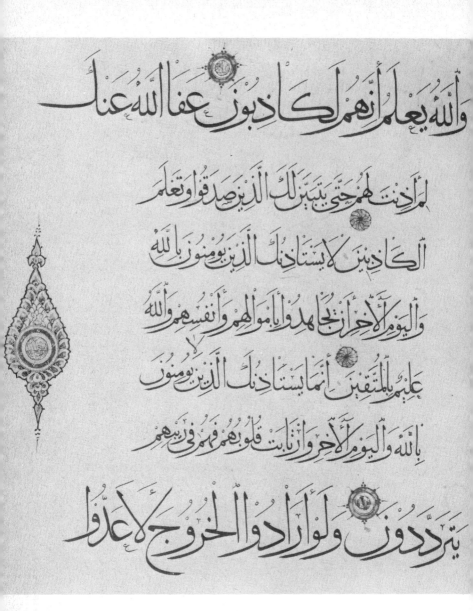

وَٱللَّهُ يَعْلَمُ إِنَّهُمْ لَكَاذِبُونَ عَفَا ٱللَّهُ عَنكَ

لِمَ أَذِنتَ لَهُمْ حَتَّىٰ يَتَبَيَّنَ لَكَ ٱلَّذِينَ صَدَقُوا وَتَعْلَمَ

ٱلْكَاذِبِينَ لَا يَسْتَأْذِنُكَ ٱلَّذِينَ يُؤْمِنُونَ بِٱللَّهِ

وَٱلْيَوْمِ ٱلْآخِرِ أَن يُجَاهِدُوا بِأَمْوَالِهِمْ وَأَنفُسِهِمْ وَٱللَّهُ

عَلِيمٌ بِٱلْمُتَّقِينَ إِنَّمَا يَسْتَأْذِنُكَ ٱلَّذِينَ يُؤْمِنُونَ

بِٱللَّهِ وَٱلْيَوْمِ ٱلْآخِرِ وَٱرْتَابَتْ قُلُوبُهُمْ فَهُمْ فِي رَيْبِهِمْ

يَتَرَدَّدُونَ وَلَوْ أَرَادُوا ٱلْخُرُوجَ لَأَعَدُّوا

Page from a Koran written in Thuluth
with illuminated margin medallions.
Probably Mamluk, 15th century.

letters, linking them using all the space available.

In Turkey, under the Ottomans, Ta'liq and Nastaliq were used from writing poetic works while Naskhi was used for the Koran, and religious and historical works, the latter being very popular with the Turks. A special script, Diwani, was however reserved for official documents, which was so complex that it was thought impossible to forge.

Naskhi was given a new dimension by the Turkish calligraphers who excelled in calligraphy of all kinds. Some of the finest works were executed for the Imperial Library. Hafiz Osman (died 1698) one of the most famous of Turkish calligraphers, invented the *Hilyah*, a formal calligraphic picture of the Prophet. The Turks also developed the calligraphic monogram or heraldic symbol, the *tughra*. Another calligraphic novelty popular in Iran as well as Turkey was the calligraphic picture of animals and birds created from a single phrase or word. With the exception of Koranic inscriptions on religious furniture such as Isnik pottery mosque lamps, pottery was not inscribed.

In India a number of scripts were used by the Islamic rulers. Fine examples of formal Kufic inscriptions are found on the earliest Islamic buildings, such as the screen of Altamish and the Qutb Minar, at the Quwat ul-Islam mosques, while at a later date both Thuluth and Naskhi were used for Korans.

It will be seen that although some scripts can be associated with certain areas where they flourished, they are not exclusive to them. Throughout the development of calligraphy, the art of book illumination developed in parallel. Illumination can perhaps be best looked on as a bridge between calligraphy and painting.

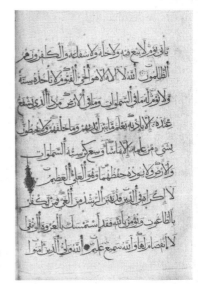

Page from an illuminated Koran showing Surah II, verses 254—9. Egyptian, 14th century.

Calligraphy by Faqir Ali in Nastaliq.
From a Moghul album. India C. 1650.

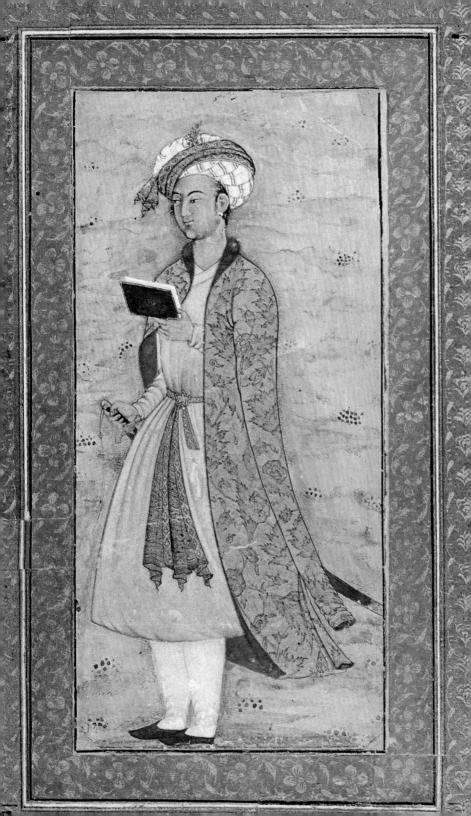

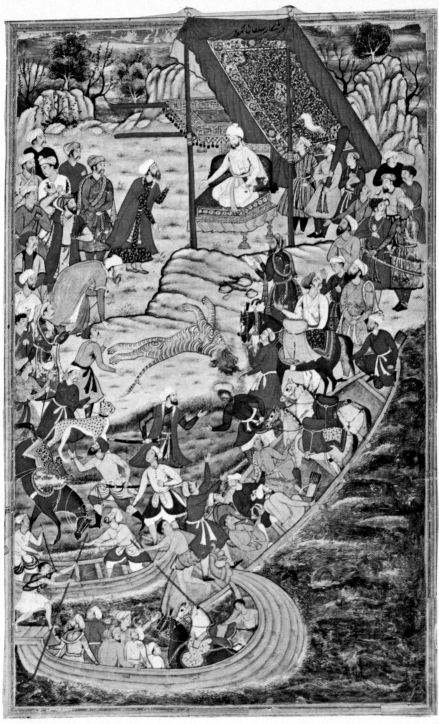

Moghul miniature painting illustrating Sultan Mahmud resting near a river during a tiger hunt. India 1580-90.

Overleaf: Moghul miniature painting of a youth, possibly Prince Salim, the future emperor Jehangir. The painting was commissioned by Jehangir himself and may be the work of Farrokh Beg or Aqa Reza Jehangiri. India c. 1610.

3 OLD MASTERS
OF ISLAM

There has always been a love-hate relationship between Islam and painting. Although closely linked with calligraphy, painting was considered a low art and the painter did not rank with the calligrapher. In spite of this some of the greatest miniature paintings of the world were executed within the confines of the Islamic world.

Islam itself has never sanctioned or sponsored painting, so religious art as such is unknown. This is in marked contrast to Buddhism and Christianity, both of which stimulated vigorous religious representational art both in two and three dimensions.
There was no religious, or for that matter, public painting in the

Bahram Gur slaying a dragon in a rocky landscape. An illustration from a manuscript of Nizami's Khamsa. Turkman, late 15th century.

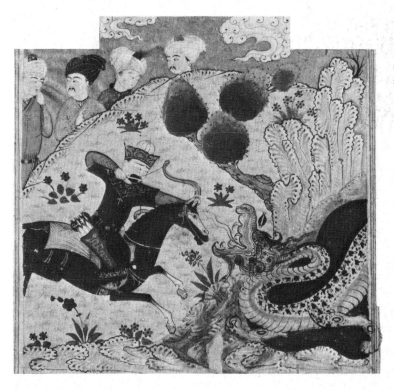

world of Islam, for painting was a private affair both in execution and appreciation. Over the centuries strong theological arguments have been made against pictorial representation of both animals and humans, in fact of all living creatures. Figurative art was regarded as an encroachment of the prerogative of Allah, an argument twisted and used in favour of painting in India under the Moghuls. Exactly what is allowed under Islam has never really been clear. There are so

Painting from the Zafarnama, the life of Timur commissioned by Ibrahim Sultan (d. 1435). The manuscript was executed at Shiraz in 1436.

many conflicting theories. It has been said that a picture is allowed providing it does not portray Allah or the face of the Prophet. Sculpture, on the other hand, is only permitted if it portrays a stylised animal. There is a story which describes how the Prophet caused the destruction of all statues and murals in the Kaaba sparing only a figure of the Virgin and Child.

The theological arguments probably arose from the fact that in Arabia, the birth place of Islam, there was no pictorial tradition. Also, from the fact that there was no religious necessity for religious representational art, its place being filled by calligraphic renderings of the word of God from the Koran. However, there have always been theological disputes as to whether or not painting was prohibited by the Prophet. The dilemma of representational art runs throughout the history of Islam.

Whatever the arguments, it is a fact that there is no religious or public painting as such and that the art of painting was not encouraged, at least publically. Painting under Islam was therefore a private art. This did not mean that it did not receive Royal patronage, on the contrary, it only meant that Royal patronage was not open and that paintings were not proclaimed and shown publically. This together with the lack of religious and public painting meant that the average man

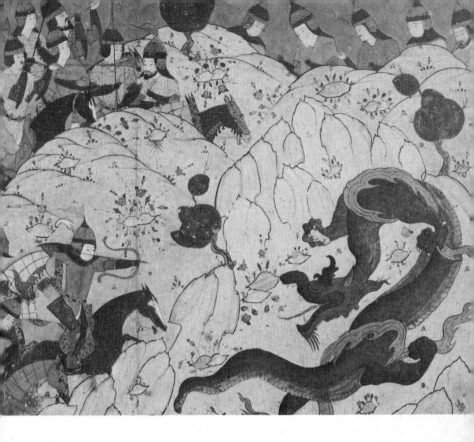

Painting from the Shahnama showing Faridun as a dragon testing his three sons. Painted at Shiraz c. 1550—1560.

was almost completely ignorant of the subject. This was a situation that bred religious narrow-mindedness and prejudice towards painting, which even the rulers had to contend with. The situation also affected the painter's subject matter. He was almost entirely confined to illustrating fine manuscripts and to miniature painting. Thus indigenous history and legend provided the majority of the subject matter.

The lack of official patronage of painting did not greatly worry the Arabs, whom as we have seen, had no indigenous pictorial tradition; but it did cut across the artistic spirits of the conquered peoples who had been converted to Islam. The Persians and Turks, whose artistic traditions predated the implanting of Islam, found that their artistic instincts could not be supressed in spite of religious dogma. Both created fine schools of painting.

The history of Islamic painting is full of contradictions, for traces of mural paintings have been found in the excavations of the 8th century Abbasid palace at

43

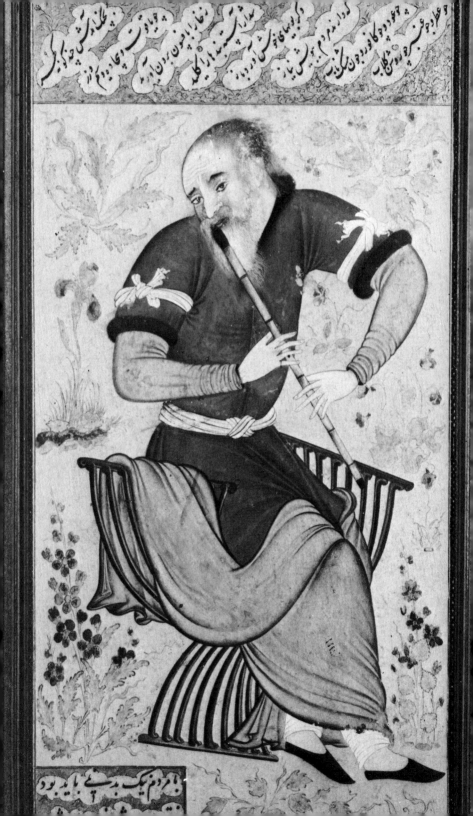

Samarra. The paintings in the harem, in Sassanian style, depicted both human and animal figures. Manuscripts also record that paintings of power themes were executed in places like throne rooms and chambers of regal splendour. A large part of early representational painting was of the power theme, usually depicting triumph in battle or the enthroned monarch - subjects that would appeal to the monarch. Paintings of battle scenes, lovers, and beautiful women on the walls of the Hamman or public bath, were also occasionally carried out, no doubt against strong theological opposition. Painting was, therefore, primarily confined to manuscript illustration. The first paintings were probably made for scholars, to illustrate works on subjects such as science, medicine, geography, botany etc. After the conquest of Baghdad by the Arabs, it became for a time a great centre of culture. Artists from Syria and Egypt, many non-Muslim, were drawn there bringing with them their own artistic traditions derived from classical and Christian sources. To this period belongs

Left: Miniature painting of an elderly musician playing a flute, seated in a "Savonarola" folding chair. The uncoloured background has paintings of flowers and shrubs in gold. Painted at Qazwin about 1560–70

the anthropomorphic illustrations to the Book of Stars, written in 965 A.D.

In the 13th century Baghdad produced one of the finest examples of illustrated manuscripts of the Middle Ages, the Assemblies (Maqamat) by Al-Hariri. Written in Arabic in 1237, the manuscript is full of lively and realistic figures of contemporary life. It is unusual in that although the text is unsuitable for illustration, it has been figuratively illustrated almost to excess, probably reflecting the popular taste of the day. There are a number of copies of the manuscript, most executed at around the same time. The paintings show a daring experimentalism that is quite unique. The figures outgrow the format which itself expands to fill not only one page but two.

Although paintings of both humans and animals were produced in Egypt under the Mamluks, it was not a vigorous tradition, the paintings being somewhat stiff and manipulated.

It was, however, in Iran that the seed of the first true Islamic tradition was sewn. With the Mongol invasion of Iran in the 13th century, a new stimulus was given to Persian art. The Ilkhanid Mongols were culture hungry were quick to patronise all the arts, commissioning many new illustrated manuscripts. The Mongols were already rulers of China, and so they brought with them not only indirect influence

of Chinese art and techniques, but also actual Chinese artists and artisans. Some influence from China had been experienced even before the 13th century, but with the Mongol conquest the influence was direct. Chinese influence can be seen in both the light airy technique of line and light colour, as well as with form and symbolism seen in the execution of water, clouds and in mythical animals such as the phoenix and dragon. This influence had a great effect on Persian painting and can still be seen in paintings of much later

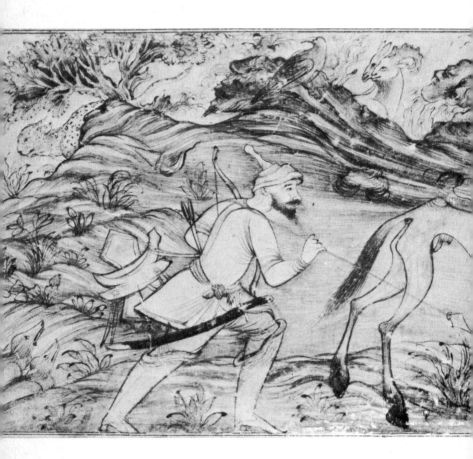

periods. A new vigorous energy can also be attributed to this Chinese influence.

It was not until the end of the 14th century that the characteristic Persian style of painting was formulated. Persia had again been conquered, this time by Timur. Under him and his descendants painting developed and flourished. Indeed, it was one of his descendants who brought the art of miniature painting to India. We can see in the paintings of the 14th century that the Chinese element had become completely assimilated to become a Persian ideal.

Until the introduction of Chinese influence to Persian painting, figures were firmly tied to the ground line, and backgrounds were of solid colour, or clear in accordance with indigenous artistic traditions. Under Chinese influence, with its traditions of unrestricted space and infinite planes, Persian painters experienced a period of great freedom, during which they emulated Chinese originals in an attempt to create a new airy Persian tradition. These experiments, although producing extremely fine works of art, did not succeed in the long run, for Muslim arts, like literature, poetry, architecture and music were organised and defined - without this order the Persian painter was virtually lost in his picture. Thus it was at the end of the 14th century, but the "high horizon" composition within defined borders became the normal

Persian miniature drawing with slight colouring of a warrior following an emaciated horse through a wilderness. Isfahan, second half of the 17th century.

format, which was to last over the centuries. Within the confines of the format, the painter had infinite freedom. Rock, trees, flowers and whispy clouds are seen throughout Persian painting, and gardens are a passion of the Persian artist.

Timur and his descendants were great patrons of painting, and under them Persian painting had its finest hour. The classic painting of this period is a pure delight to behold. These miniature "treasures" are masterpieces of composition and colour, with a fineness of detail which gives them an air of absolute perfection. The painter was master of everything he beheld, he could do with it what he liked. However, he did not lie, he was truthful to the point of ignoring what he saw, only portraying what he knew to be there. Thus, illusions have no place in Persian art. Rich decorative detail and naturalism were all important. Some of the finest works were produced in Shiraz, under Iskandar-Sultan (died 1414) and in Herat under Baysunqur (died 1433) and Sultan Husain Bayqara (died 1506).

Bihzad, one of the greatest masters of Persian painting, worked for Sultan Husain in Herat until it was taken by Shah Ismail, the first of the Safavids. He then moved to Tabriz where he was made director of the Royal Library. He may have actually left Herat for Bukhara in 1507, after the conquest by the Uzbegs, for he is not recorded in Tabriz until

1521. Bihzad was a master of naturalism and expressionism and the figures in his paintings are full of emotion. They are powerful and dramatic. His subjects however were not that original, being drawn from traditional Persian themes like Nizami's *Khamsa*, but his interpretation was. His paintings are masterpieces of colour and pattern which in no way overwhelms the detailed treatment of the figures. Another artist of Herat who worked in similar style was Qasim Ali.

During the early part of the 16th century there was considerable movement of artists from one court to another, due to the unsettled political situation. After the Safavids captured Herat, all the court painters were moved to the Safavid court at Tabriz, where the classical style continued, greatly influenced by Baghdad. Mir Sayyid Ali of Tabriz, a painter of great talent, was to have a profound effect on the formation of the Moghul school of painting, when he founded the court atelier of the Moghul Emperor Akbar. This was after the Safavid ruler, Shah Tahmasp had withdrawn his patronage of painting.

Persian painting had been greatly dependent on Royal Patronage, and this withdrawal of Royal assent was nothing short of a catastrophe. Many of the best painters left the court, some like Mir Ali, went to the Moghul court in India. Others stayed finding

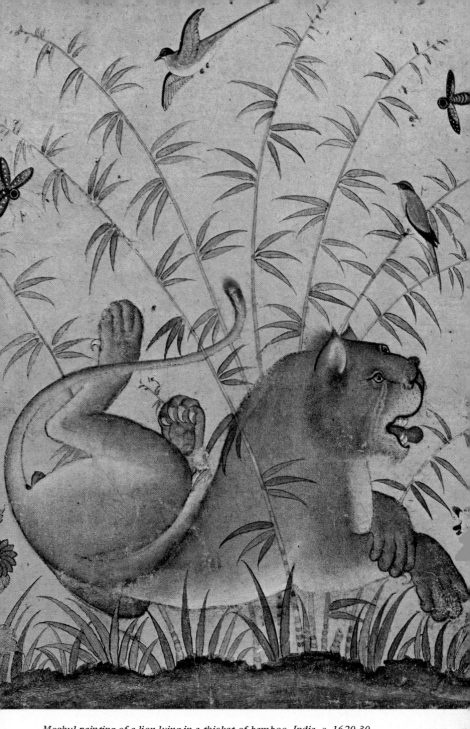

Moghul painting of a lion lying in a thicket of bamboo. India, c. 1620-30.

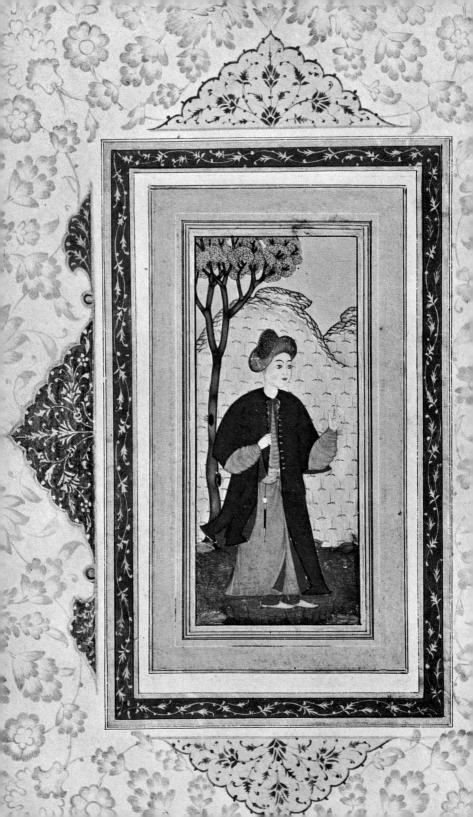

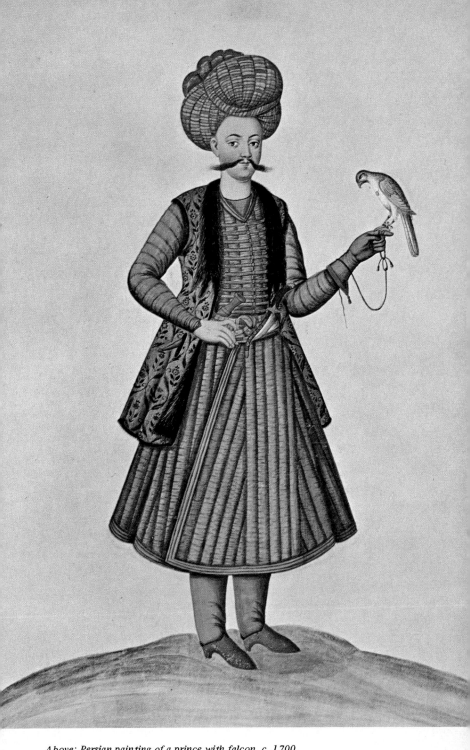

Above: Persian painting of a prince with falcon, c. 1700.

Left: Turkish miniature painting of a young man wearing a blue kaftan. Circa 1620.

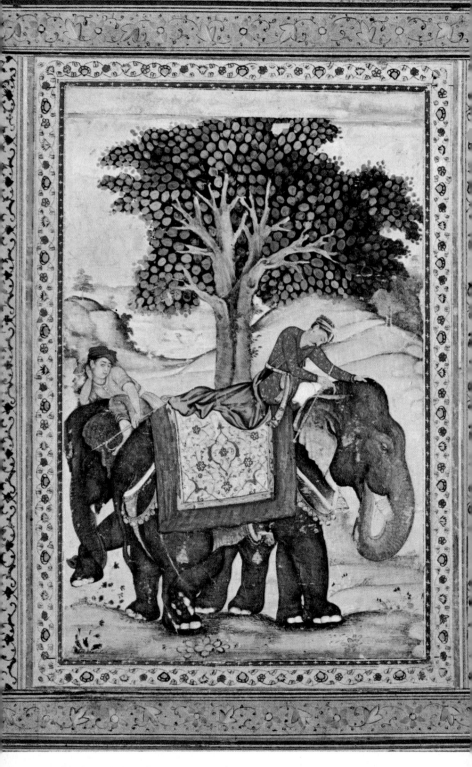

Moghul painting of two elephants with their mahouts resting beneath a tree, India, c. 1615.

Tinted drawing of the Queen of Sheba. Persia, about 1600.

and silver. Whereas the colours in Persian paintings are subtle and delicate, those in Turkish paintings tend to be stronger and a little harsh, with shades of blue, green, purple, and red predominating. The paintings are in keeping with Islamic tradition and like the Persian avoid atmospheric effects and optical illusions. Turkish paintings are to a great extent reportage of historical and sacred events, whereas Persian paintings tend to be romantic interpretations of poetry, myth and history. The Turkish painter was a master of crowd scenes, which he recorded with vivid realism and detail. At first, as the Turks were fond of military expeditions, many of the paintings recorded battle scenes, victories and triumphal processions. Later, with a decline in military activity, painters concentrated on festivals and important social events.

There was a preference in Turkish paintings for larger figures, frontal views and full profiles, whereas the Persian artist preferred the three quarter profile.

The earliest recorded Turkish painter, Sinai Bey, a painter at the court of Mehmed II (1451-81), is mentioned in the first written account of Turkish artists *Menakib-i hunerveran* by the historian Ali. However, Ali's account of the painters and their works is rather brief, as the majority of the book is devoted to the work of calligraphers, painting being regarded as a second class art. However Ali's account is interesting for most Turkish miniatures are unsigned and even where they are signed, the authenticity of the signature is somewhat dubious, therefore we cannot rely on the paintings to tell us much. Ali records that in the 16th century Aghn Mirak, the

Persian painter from Tabriz came to Turkey in the reign of Sulayman. Another artist, also from Tabriz was Velican. Perhaps the most interesting information in Ali's account is the large number of non-Turkish artists who worked in Turkey, a fact which accounts for the cosmopolitan quality of Turkish painting. The predominant foreign influence was Persian, but there were also many others. The earliest Turkish painting is influenced by the Persian Herat style, and the later painting of the 16th and 17th century by the Safavid style. Some influence from Europe and the Far East, in particular Italy and China, was also felt. Thus, Turkish painting can at one and the same time display many influences, but always has a typically Turkish air about it.

Perhaps one of Islam's greatest art forms can be said to have had its birth in India. Born of Indian inspiration and Persian ingenuity, schools of miniature painting developed in the sub-continent which produced masterpieces that rank among the worlds greatest. These delightful paintings, the products of numerous schools and artists are extremely pleasing.

Indian miniatures have been

Miniature painting of a lion resting. The background is uncoloured. Isfahan, early 17th century.

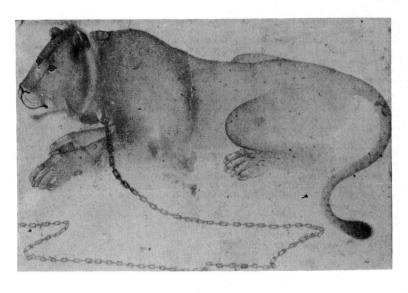

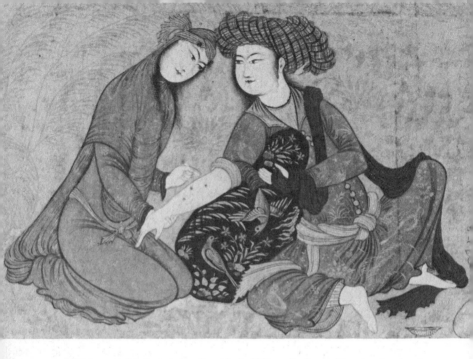

Persian miniature painting by Afzal al-Husayni of a maiden treating her lover with acupuncture. The painting, although executed at Isfahan in 1646 was mounted in an Indian album.

known in the West since the 16th century. Rembrandt was familiar with them and made free copies of them. In the 18th century large private collections were made by Richard Johnson and Sir Gore Ouseley.

The art of minature painting in India may be said to have begun under the Moghul emperors, the descendants of Timur. Although there was an earlier indigenous non-Islamic tradition of miniature painting, these were mainly sub-miniature book illustrations painted on thin horizontal leaves of paper or palm, and not rectangular leaves, the format of the Indian miniatures. The Moghul tradition however was influenced by these early schools.

The Moghuls, after their suc-cessful invasion of India under Babar, in the early 16th century, brought to their court from Persia. painters versed in the art of miniature painting. These painters employed local artists in their ateliers, who were proficient in the indigenous style. Soon a new school of painting was born, the Moghul school, which certainly ranks amongst the greatest in all Asia.

Right: Portrait of a Turkish Sultan, possibly Murad I or Bajazet I. Turkey, Late 16th century.

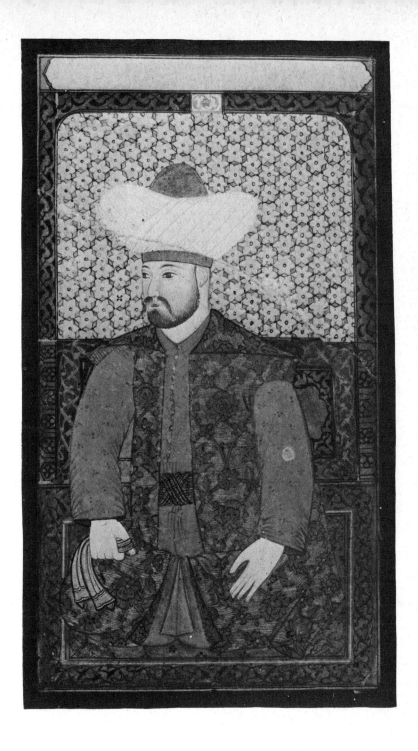

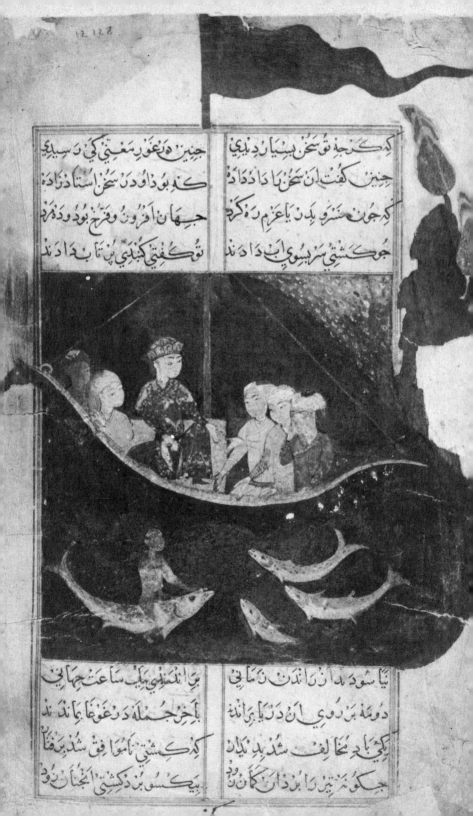

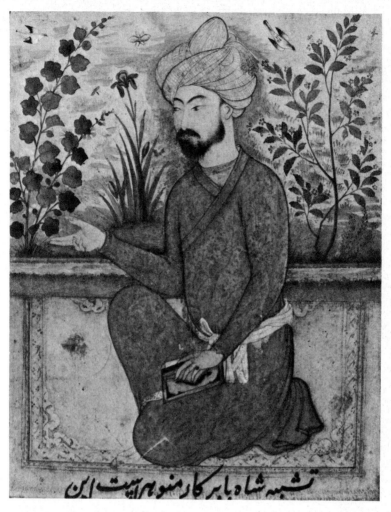

تشبيه شاه بابر كار منوهر بيت این

Portrait of Babar, the founder of the Moghul dynasty, kneeling on a carpet, with an inscription below. Attributed to Manohar. Moghul c. 1610.

Left: An early Islamic painting from Sultanate India, probably from the Deccan or further south. The subject, a king caught in the storm at sea at night shows the strong Persia influence current in India at that time. 2nd half of the 15th century.

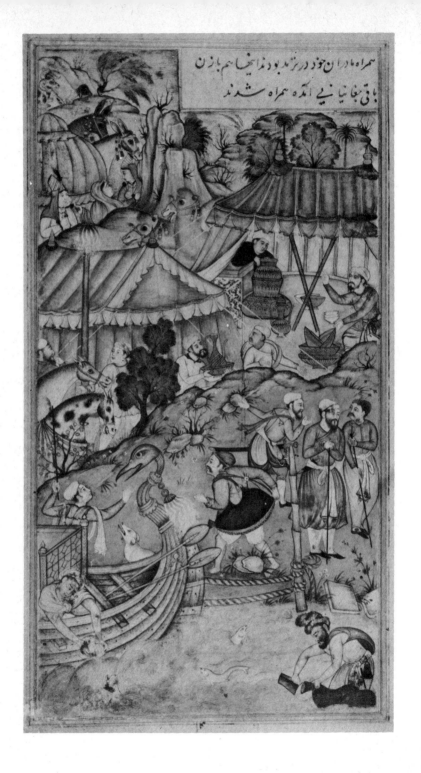

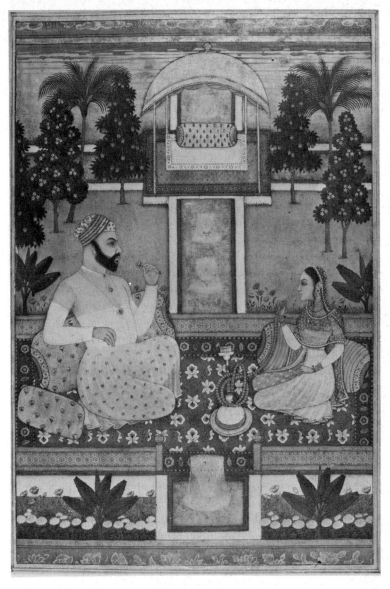

Above: Indian miniature painting of a nobleman seated on a terrace, with a maiden smoking a hookah. Deccan, first half of the 18th century.

Left: Moghul miniature painting from the Babarnama - the life of Babar. The painting depicts Babar's follower's camp on the bank of the river Oxus. The drawing is by Basawan and the painting by Husain. Moghul c. 1590.

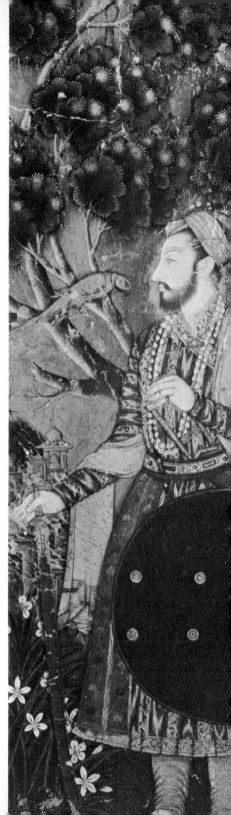

The emperor Akbar (1556-1605) Babar's grandson, can be said to have been the real founder of the Moghul school. It was under his personal supervision that the court studios grew up, staffed with local artists under the direction of Mir Sayyid Ali and Abdas Samaad, two master painters from Persia, who had come to India with Akbar's father, Humayan. Of the local artists, among others we know the names of Basawan, Daswanth and Kesadosa. Some accounts say that there were over a hundred artists working in the capital.

Akbar was a great patron of the arts and commissioned many large projects. One of the largest was the *Hamza Namah* consisting of 1400 paintings on linen, started about 1567 and completed 1582. Artists came to Akbar's court from all over India to work on the project. The painting of this early work shows a very strong Persian influence but later this was modified under the influence of both Hindu and European ideas.

The average size of Indian miniatures of the 16th century measures about 12 inches by 8 inches.

An Indian miniature allegorical painting of a prince, attributed to Farrokh Beg. Moghul c. 1610.

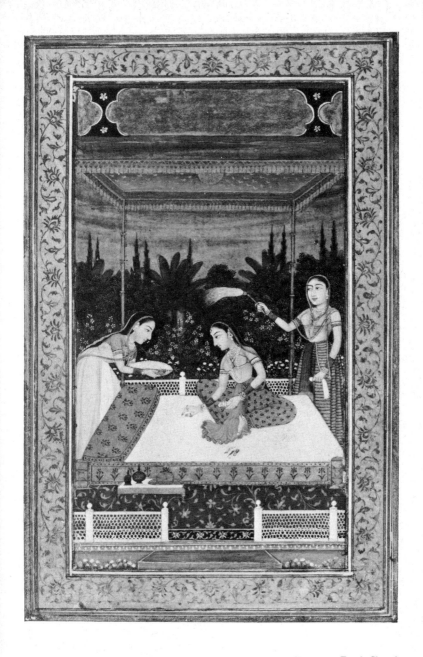

Indian miniature from a Ragamala series, painted by Faqir-Ullah and Fateh Chand.
Mid 18th century, Deccan School.

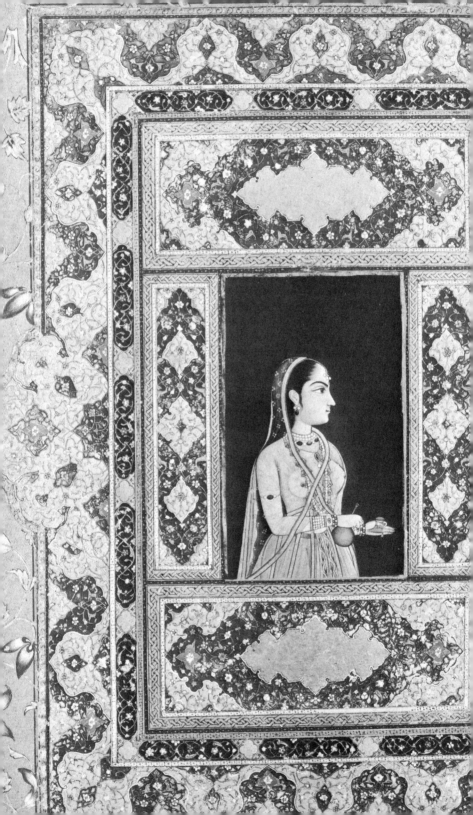

Subjects of Moghul paintings included scenes from actual life, historical incidents, portraits, etc. The emperor Akbar specially commissioned many Hindu epics and other works to be illustrated for his library.

The earliest pictures, sometimes described as Indo-Persian were painted in similar technique and materials, in reds, blues and golds - a kaleidoscope of colours. The blues were ground from lapis lazuli. Gold leaf was frequently used on backgrounds and for the designs and accessories of costumes. The fine and delicate painting is closely related to the Persian style.

The true Moghul miniature is however quite different. It is freer and more realistic than the earlier works and the background is generally more natural. The introduction of fine line shading is probably due to European influence. The Moghul painters had a unique sense of perspective and many attempts were made at foreshortening.

The care that the Moghul artists lavished on their work can be seen in the trouble they took

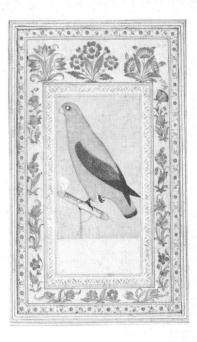

Moghul painting of a parrot, inscribed "Amali Khizr Naqqash" (the work of the painter Khizr). Moghul c. 1620.

in the choosing and preparation of their materials. The technique is similar to that used on Persian and Turkish miniatures, though is somewhat different to that used on integral paintings on parchment manuscripts. Artists made most of their own pigments, many to their personal formulas. Paper was made from bamboo, jute and cotton, while a fourth variety, made from flax was used occasionally.

Once selected, the paper was burnished with an agate pebble to give it a uniform enamel-like surface. For separate paintings, two pieces were used, stuck

Indian miniature painting of a girl. The painting is mounted on an album leaf with a border of illumination from a 16th century Persian manuscript. Moghul, third quarter of the 18th century.

Right: Detail of a Moghul miniature painting showing Iskandar by a tree in discussion with a sage. India late 17th century.

together, back to back, while single sheets were used for book illustration. Brushes were made of squirrel, monkey or camel hair. The pigments, which were made from natural substances, were applied with water mixed with binding agents, such as gum, sugar or glue.

The outlines were always made first in Indian red, which as it was not mixed with binding agents, could be easily removed. After being primed with semi-transparent white, this outline was blacked in with lamp black.

Often more than one artist was employed on the production of a picture. One would specialise on the drawing of the outline, another on the main subject and, sometimes, yet another on the background. As in European schools, apprentices worked under the direction of masters, painting in minor areas, but the resulting work was always known by the master's name. The mounting was not the work of the artist, but of another individual, a specialist in his field. There was usually a buffer area between the panel and the border, a band of solid colour, sometimes decorated with flowers etc. The border was commonly speckled with gold leaf.

It was during the reign of Akbar's son Jehangir (1605-1627) that the flower of Moghul painting bloomed. He inherited his father's studios, commissioned many works and formed collections, both of contemporary and early

paintings. These were mounted in uniform size in large albums. Elaborate floral borders seem to have been specially developed by Jehangir's court ateliers, possibly for the purpose of enhancing the overall appearance of the royal albums.

During Jehangir's reign the style became more naturalistic. The Persian idea of bird's-eye perspective was replaced by the popular side view of the indigenous, non-Islamic Rajput style. Jehangir commissioned botanical and zoological studies. These beautiful and delicate paintings are masterpieces of Moghul art. Other subjects popular at the time include illustrations of historical works, romances, hunting scenes and group portraits. Single portraits, too, were very popular and many are works of sheer genius. Amusing paintings of Europeans and copies of occidental paintings were also executed. European art had a marked effect on the art of the Moghul court, which can be seen in the introduction of faint line shading, giving a quality of depth to the otherwise flat style.

There is a recorded instance of an artist working in India, who had actually studied under Italian masters in Rome in the early 17th century. Muhammad Zaman, a Persian artist, studied in Rome, became a Christian and changed his name to Paolo Zaman. He was not allowed back to Persia and obtained asylum under the

emperor Shah Jehan in India, where he worked as a painter. He later returned to Persia where he had strong influence on the art. At least three paintings in the European style in the British Museum are thought to be by him.

During the reign of Shah Jehan (1628-1658) a technique known as *Siyshi Kalam* (line drawings with just a touch of colour) became very fashionable in portraiture, reflecting the contemporary Persian fashion.

The flower of Moghul painting begins to wilt a little during this period but does not completely die for nearly 200 years. Portraiture in the Moghul court was extremely popular. Royal personages are nearly always shown with a halo of gold around their heads. The portraits are true to life and drawn with fine and delicate lines.

The figure was usually shown in profile, the garments richly painted in mosaic colouring, enhanced with gold. When diaphanous robes were painted, the limbs were shown clearly beneath the folds. Backgrounds were usually plain, painted in tinted colours, though occasionally dark colours were used. The artist relied on the colouring and delicate line drawings for effect.

The stiffness of Moghul portraits is relieved somewhat by the soft natural treatment of the hands, which, in the case of men, are often shown resting on the sword-hilt or holding a flower. The Moghuls, like the Persians were very fond of nature and it was not considered unmanly to be portrayed like this.

Moghul painting declined under the emperor Aurangzeb (1658-1708), as this despotic ruler took no interest in the work of the painters due to his puritanical beliefs. Paintings, however, continued to be made, though the subjects were mainly court, hunting, war scenes, and portraits.

In the 18th century Moghul painting entered a new phase. From the time of Akbar until the death of Shah Jehan, painting was a royal art, produced for emperors, princes and the nobility, but by the 18th century, painting had grown popular with the merchant classes and people of similar status.

Miniature painting and manuscript illustration, however, is only part of the art. For throughout the Islamic world, with minor exceptions, there was another side to the art of painting, that of painting on pottery.

4 WONDROUS LUSTRE, POTTERY AND PORCELAIN

Islamic pottery draws together both calligraphy and painting, combining them within the third dimension of shape. The art of ceramics was a public art, thus, to a certain degree, painted and decorated ceramics are a substitute for both public painting and sculpture.

As with painting, China exerted a reasonably strong influence on Muslim ceramics, both before and after the Mongol Ilkhanid conquest of Persia. Excavations in Islamic countries have brought to light Chinese porcelains and celadons in association with indigenous pottery, and it is possible to see a direct influence both on the form and decorative motifs from about the 8th

Persian slip painted bowl (Samarkand ware). 9th–10th century.

century A.D. This Chinese influence, however, appears in a strong form only sporadically and it is evident that although it was a constant influence, Islamic potters did not seek imitation as their one and only goal. Chinese ceramics were no doubt, however, greatly admired and valued in Islamic countries, and it was this admiration, both on the part of the potter and his patron, which led to the attempts to imitate Chinese ceramic achievements.

In Mesopotamia in the 9th century, polychrome glazes similar to those of T'ang China were made, but attempts to reproduce porcelain were generally unsuccessful, due to the absence of suitable clay. Early attempts generally had a thick tin glaze over the red pottery. However, in Iran under the Seljuks in the 12th century, a fine white ware was produced but it was not true porcelain, being made of white pipe clay and a white translucent material composed of a glass like substance.

Islamic potters did not always follow behind the Chinese, in many cases they anticipated them, and their techniques and technology laid the basis for the Italian majolica of the Renaissance and the European painted pottery of later times. Although Chinese designs and decorative motifs are reflected in

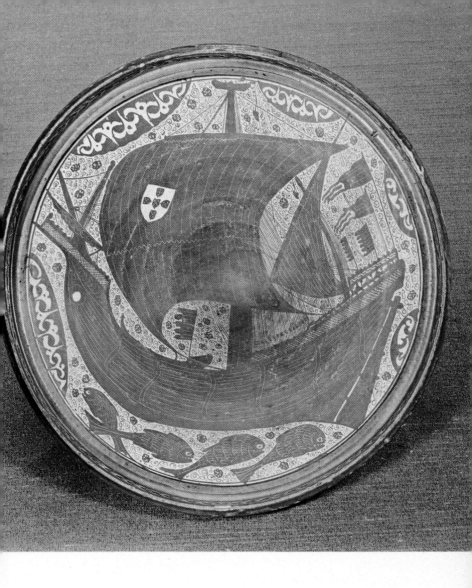

Hispano Moresque ceramic bowl painted in lustre and blue with a design of a Portuguese ship. Manises, Spain, early 15th century. Lustre, first perfected in Egypt, manufactured in Persia, Mesopotamia and Syria, reached a new brilliance in Spain, as can be clearly seen in this magnificent example of the potters art.

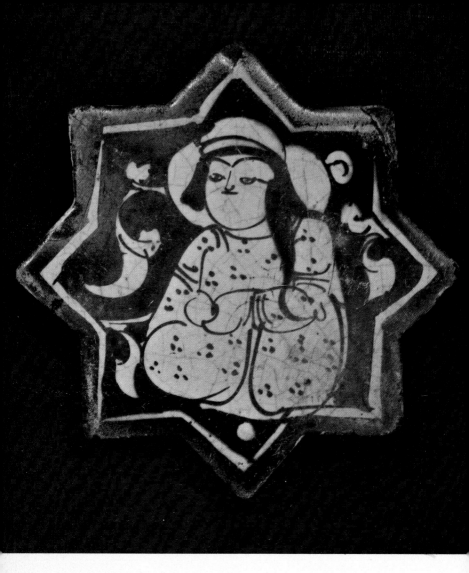

A lustre painted ceramic star tile. Ceramic tiles were used in large numbers for the interior decoration of mosques palaces and tombs. Persia, Rayy, c. 1200.

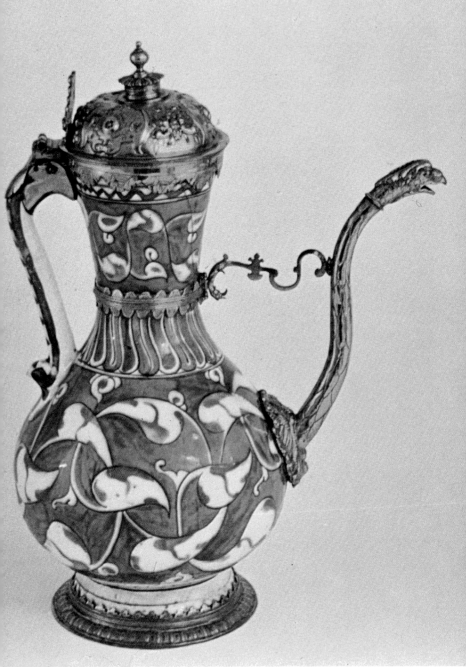

Splendour in gold and ceramic, can be seen in this 16th century Turkish Isnik ceramic vessel with gold spout, lid and foot.

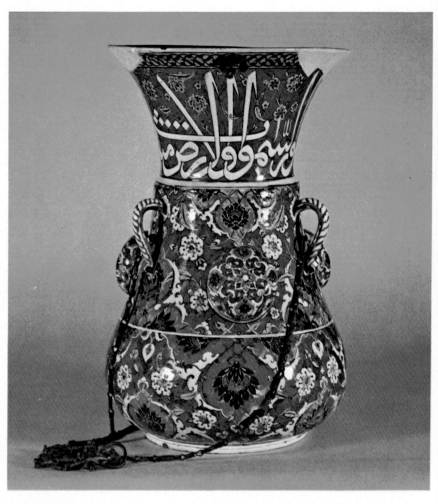

Multi-coloured ceramic mosque lamp made at Isnik for the Sulaymaniyeh Mosque, Istanbul. 16th century.

some Islamic wares, sometimes to the extent of the entire design, such as in the case of 17th century Persian blue and white ware, Islamic artistic ideas were predominant. The art of painting on pottery was vibrant, almost explosive, and in many cases it could be argued that painting on pottery was more alive and free, and to that degree a truer art, than the more controlled renderings in manuscripts and miniature paintings. It was certainly the case with calligraphy on pottery and it is no exaggeration to say that some of the finest examples of the calligraphers' art can be found adorning pottery of all shapes. Pottery also provided a meeting place where the artist blended both abstract, floral, geometric and figurative art, using whatever theme or device necessary for his purpose.

Many of the decorative devices were symbolic and had a magico-religious significance. The most popular purpose for this symbolic treatment was to propitiate the elements and to ensure rain, good harvests, healthy animals etc. This is not unusual as pots are mainly associated as food containers and therefore inscriptions related to ensuring the supply of food seem appropriate. What is, however, unusual is the combination of magical and astrological elements in a religion so vehemently biased towards monotheism. These motifs may however be explained as a survival of pre-Islamic

traditions, many of which hark back to prehistoric times.

The divisions of the geometrical or abstract design and the number of elements within are usually of great significance and may be related either to astrology or the magical properties of numbers. The number eight is particularly powerful, and occurs frequently on pottery, both as octagons, lobes or divisions. Colours are also significant and full of hidden meaning. The preference for Chinese blue and white is in some way explained by virtue of blue, white and gold being the colours of Islam. The popularity of gold lustre ware throughout the Islamic world can perhaps be explained in a similar manner.

Many of these designs and motifs are common to all the Islamic world, while others are purely local. Animals, both natural and mythical are a common feature, and plants appear in various forms from natural representations to geometrical patterns. There were no accidents of design, no matter how accidental they may look, everything in the design had a meaning and was painted with intent. Human figures are of great interest as they often reflect contemporary life showing musicians, hunters, and other social occupations.

A large variety of vessels were made, encompassing all shapes and sizes, including plates, bowls,

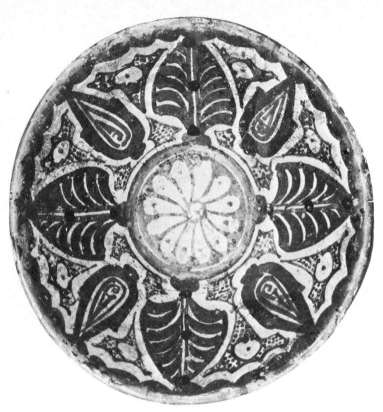

Earthenware bowl painted in a blue green vermilion and purple on white slip. Samarkand type, 9th century.

bottles, jugs, beakers, candle sticks, oil lamps, incense burners, vases and even statuettes and toys, though the latter are not very common.

Lustre ware truly reflects the genius of the Islamic potter. There are conflicting theories as to its origin, but it most probably originated in Egypt in the 8th century A.D. where it was used for decorating glassware. The same technique was used on pottery probably by the same glass workers. The technique is basically quite simple. The pot is first fired in a high temperature kiln. Then the design is painted in metallic oxides of silver and copper onto the glazed surface, and fixed by a second firing in a special kiln at low temperature. This turns the oxides into a warm gold lustre varying in colour from gold and copper red to brown and olive. Lustre became popular almost simultaneously in Mesopotamia and Persia and later in Syria and Spain. The design could be either in positive or negative.

In Mesopotamia both mono-

alternative patronage in Persia. Paintings patronised by the court were extremely expensive to produce, so much so that ex-royal artists had to modify their paintings to suit the pocket of their less wealthy patrons.

The result was a change from sumptuously illustrated manuscripts to simpler miniature paintings and drawings. Changes also occurred in the paintings themselves. The occasional practice of extending the subject beyond its borders now became the norm. Elements of landscapes were modified and figures became less realistic, until by the end of the 16th century, the human figure had taken on an entirely different dimension. Both line and tinted drawings were extremely popular.

Before Shah Tahmasp withdrew his patronage, a new and brilliant style had evolved at Tabriz, under a number of great artists including Mirak, Sultan Muhammad and Ustad Ali. Their eye for harmonious colour produced painting of outstanding subtlety and delicacy. Deep blues, gold and a kaleidoscope of colourful flowers feast the eye. Animals, birds and humans are all animated with superb skill.

In Persian art the same themes recur time and time again. Poetry, historical and mythological works were extremely popular. Themes like Nizami's *"Khamsa"* or five poems, Firdansi's *"Shahnama"*, Sa'di's *"Bustan"* and Jami's story of *Joseph and Zulaikha* are illustrated with originality by numerous painters. Several figures recur so often that they are easily recognised. They are Rustam in single combat, slaying the White Ogre etc., Shirin bathing, Khusrau shown alone and with Shirin, Bahram and many others.

The dominence of calligraphy reasserts itself in the second half of the 16th century, when a style of painting using sweeping calligraphic strokes, resembling the Nastaliq script was developed. Two leading exponents, the librarian of Shah Abbas the Great, Sadiqi Beg, and the painter of the Isfahan School, Riza-i-Abbasi. Riza, an artist of marked individuality, was active in the first half of the 17th century. His work reflects the popular taste of the time, for sensuous, somewhat erotic works. He was a master of deliniation, and portrayed almost to excess the pleats and folds of garments, the long wavy strands of hair, all of which accentuated the human form into a sensuous and sometimes erotic symbol.

Although influenced by the Persian miniature tradition, Turkish painting is quite different. There is always an indigenous element which marks it as "Turkish". Apart from the obvious differences in costume, there is a difference in the landscape which accurately reflects the somewhat austere nature of the terrain. The colours, too, differ as well as the use of gold

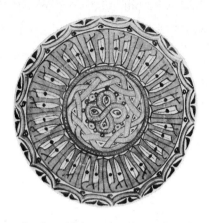

Bowl, reddish earthenware painted in white, red, blue, green and brown black slip under a clear glaze. Samarkand type. 9th–10th century.

chrome and polychrome lustre was produced, common designs being stylised floral motifs, geometric patterns and the double winged motif and palmette derived from Sassanian prototypes. Figurative motifs did not appear on early lustre. Some of the finest examples of lustre ware came from Samarra in Mesopotamia which suggests that they may have been made for the Abbasid caliph.

Our knowledge of Mesopotamian pottery has been greatly aided by a study of the finds from excavations at Samarra. Various forms of pottery have been classified and two types of pottery decorated in relief are known. Barbotine ware has the decoration applied to the pot in relief as a thin paste, while the other is moulded. Barbotine pots were not glazed. White pots decorated by the moulded method were glazed in yellow, green and occasionally in lustre. Far Eastern influences

can sometimes be seen in the decoration. Vessels of these kinds are amongst the loveliest Islamic pottery ever found. Made at Samarra and Susa was a white ware covered with thick cream coloured tin glaze and decorated in a bold manner in blue, green, and occasionally with brown and yellow.

Sgraffito wares of two kinds were also extremely popular. In one the design was scratched through a white slip to reveal the red or buff body beneath; the pot was then covered with a thin yellow glaze. When fired the areas where the white slip had been cut through showed up darker than the surrounding areas.

White earthenware tankard decorated in black slip. Inscribed "blessing to the owner." Persia 12th century.

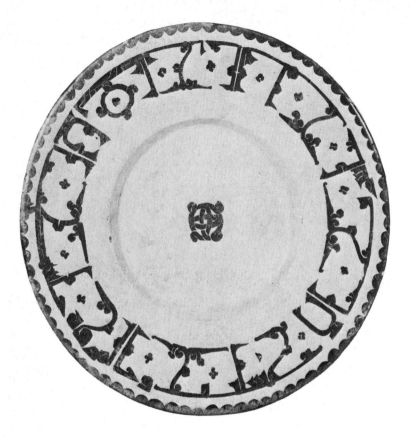

Ceramic dish. Lead glazed with slip decoration. Persian (Nishapur) 9th—10th century.

Polychrome sgraffito ware is reminicent of the polychrome glazed ware of T'ang China.

The earliest Islamic pottery in Egypt was imported from Mesopotamia, but after the breakaway from the Abbasid caliphate and the establishment of the Fatimid dynasty, Egyptian potters soon evolved a whole new style of their own. The Fatimid influence extended over a wide area and was felt as far away as Sicily, Southern Italy, and Andalusia. The Fatimid style is extremely rich and is marked by the exuberance and originality of the painting which harmonises with the shape of the pot. Human and animal figures figure prominently and are executed with such skill that they seem to move across the vessels. Lustre was developed and reached the peak

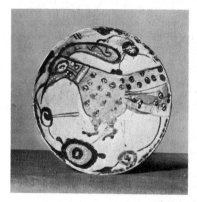

of perfection in the 11th and 12th centuries. The fabric of the pot itself was somewhat coarser than the lustre ware of Persia and Mesopotamia, but the painting and lustre itself was superb.

It appears that the Islamic potters often decorated pots with Christian motifs for their Christian patrons. One such lustre bowl, in the Victorian and Albert Museum, London shows a Christian priest swinging a censer. The bowl, which dates to the first half of the 12th century is signed Sa'ad. A number of artist potters of the Fatimid period signed their names on lustre ware. Foremost amongst them was Sa'ad, and Abu'l-qasam Muslim ibn ed-dahhan. Sa'ad's style shows a great sense of proportion and accuracy combined with a grace typical of the period. Muslim, who lived at the beginning of the 12th century painted in a simple, vigorous and slightly archiac style. Some of his work is in the Museum of Islamic Art, Cairo.

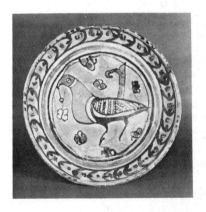

During the Fatimid period there was an exchange of artistic motifs between Byzantium and Egypt, thus we find Fatimid pottery often decorated with Byzantine inspired motifs, while some Byzantine pottery has been found decorated with arabesques and Kufic script. A number of figures on Fatimid pottery have a very Hellenistic air about them.

Apart from the very popular lustre ware, an Egyptian version of T'ang polychrome ware was

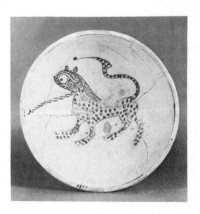

made in Fazzoum. At the end of the Fatimid period, in the 12th century, sgraffito ware was manufactured which had splashed colour decoration over the transparent glaze. A fragment of this pottery signed by Sa'ad (whose lustre ware bowl was mentioned earlier) in the Museum of Islamic art, Cairo, suggests that potters were versatile working in a number of techniques. The decoration in many cases is not just scratched but carved, and perhaps was influenced by Chinese celadons. The manufacture of this kind of pottery continued through the Ayyubid and Mamluk periods until the 15th century.

The Ayyubid dynasty, which lasted for eighty years, was founded by Salah-ed-Din Yusuf ibn Ayyub (Saladin), who displaced the Fatimid caliph in 1171. It was the Ayyubids who fought the Crusades and their military activity is perhaps reflected in the austere Ayyubid style. The Mamluks, who seized power in 1250 extended their rule to form an Egyptian empire which included northern Mesopotamia and Syria. They loved comfort

Painted bowl, Rayy style from Sultanabad. Late 12th century.

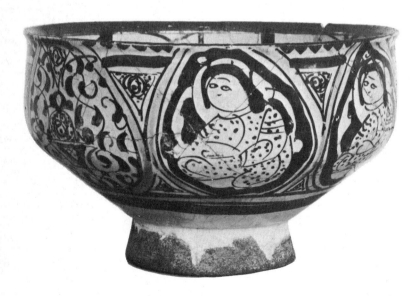

78

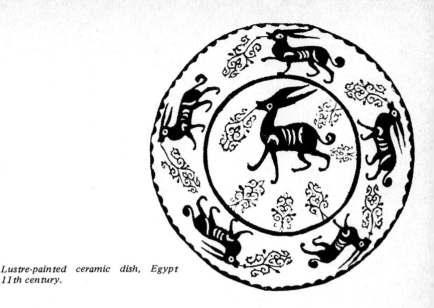

Lustre-painted ceramic dish, Egypt 11th century.

and riches, a fact which is reflected in the beautiful metalwork as well as the enamelled glass and the fine pottery of the period.

A new form of pottery was developed in the 13th and early 14th century. A polychrome ware in which the rather painstaking designs of humans, animals and birds, combined with arabesques and similar devices, were painted in polychrome and sometimes in black and covered with a fine transparent glaze. Here again the names of some of the potters have survived, which enable us to associate particular styles with actual artists, names such as Ghaibi, Hormozi, Abu'l-Izz and Ghazal.

Two more styles prevailed during this period, one indigenous and the other inspired by the blue and white porcelain of Ming China. Ghaibi appears to have been influenced by the Chinese, for a vessel in the Museum of Islamic Art, Cairo, is signed by

him in a manner imitating the signature seals of Chinese ceramics. Another form of pottery popular during the Mamluk period was an enamelled red painted pottery in which the designs were painted and incised under a transparent glaze.

An important centre for Persian ceramics both under the Samanids and Seljuks was Nishapur in Khorasan. The early pottery can roughly be grouped into four types. In one, the design was painted in black on a smooth white ground and covered with a thin glaze; in another polychrome designs were painted on a reddish-buff body and covered with a transparent glaze; while the third group is distinguished from the others by its dark brown glaze on which was painted floral motifs in red and white. Lastly there was a sgraffito ware with green and yellow glazes inspired from Chinese T'ang prototypes. A similar ware has also been found at Hira, Rayy, and Saveh. Sherds

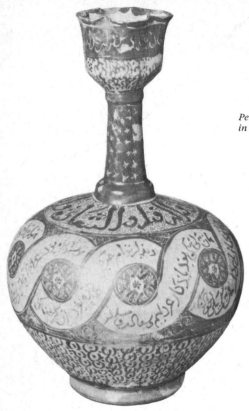

Persian tin glaze ceramic bottle painted in lustre. From Kashan.

of Chinese celadon have been found in archaeological excavations at Nishapur, which again point to strong Chinese influence.

The Samanid capital of Bukhara and one of their most important cities, Samarkand in Transoxiana, also produced distinctive pottery. One kind known as Samarkand ware was produced over a long period. The vessels made in this ware are of a reddish pink clay covered with a red, black or white slip onto which designs were painted, the whole covered in a thick transparent colourless glaze. Calligraphic designs in Kufic were used to great effect.

Under the Seljuks, extremely fine white stoneware decorated in splashed or mottled glazes in red, yellow and green, was produced at Nishapur,. In the 12th century, the potters surpassed themselves by producing exquisite vessels in white ware decorated with carved and pierced designs. Both recall Chinese parallels. Lustre ware was also extremely popular and many superb vessels rivalling those of Egypt were produced by Persian potters. An important centre for lustre was Rayy which is also famed for pottery of other kinds. Other famous centres for ceramics include Kashan Sawan, Sultanabad, Veramin in north-

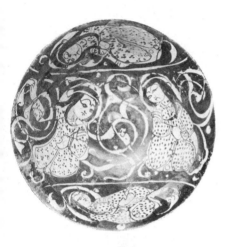

White ceramic bowl, painted in yellow lustre with blue glaze under the foot. Found at Khar near Tehran, Persia (Rayy). Late 12th early 13th century.

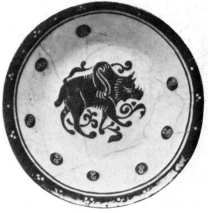

Grey glazed earthenware bowl, decorated with incised details. Persian late 12th or early 13th century.

White ceramic dish with blue glaze. Persian, (perhaps Kashan). Mid 12th century.

81

west Persia, Sari and Amol. In the 11th century, Persian potters began to experiment and break with some of the old traditions to produce new and original types.

During the 12th century, a thick pottery with a carved decorated surface covered with a thick glaze of blue, brown, or green, became popular. Also in the 12th century Laqabi ware mainly made in Kashan was popular. In this ware the decoration was carved in relief on the body, the areas of relief were coloured in polychrome against a white or cream ground, and then covered with a transparent glaze. The effect is something like cloisonnee. The colours often ran into each other especially on vertical vessels.

The fashion for carved and incised ware led to the designs being moulded. Many moulded pots were simply covered with a transparent glaze of dark blue or turquoise. A black silhouette ware with the designs painted in black under an ivory or turquoise transparent glaze was also popular during the 12th century. The designs were mainly of calligraphic inscriptions in Kufic or Naskhi, and animal and human silhouettes.

Besides the pottery made at Rayy and Kashan, there were other centres of production which produced pottery between the 12th and 14th centuries. One such was Sari, in the Mazandaran province south of the Caspian Sea, which produced pottery painted in polychrome slip in green, black, red, brown and orange, and manganese. Favourite motifs were stylised birds and floral designs. Amol, also in the Mazandaran province produced pottery decorated with calligraphic, geometric and figurative patterns incised onto a cream background, then coloured in green. Gabri ware is notable for its negative/ positive designs formed by cutting out the background of the design after it had been incised onto the vessel, leaving the design standing in white slip, surrounded by the red body of the pot. The skill with which the Persian potters produced all these sgraffito wares is to be admired for they had complete mastery of colour, whether they applied it over or under the glaze.

Perhaps the finest of the polychrome decorated pottery is the so-called Mina'i ware, developed towards the end of the 12th century. The motifs were sometimes painted in up to seven colours under the glaze and sometimes over the glaze, according to whether the vessel was to be fired at a high or low temperature. The fineness and superb quality of the Mina'i painting, especially figurative paintings illustrating stories from history and even poetry, are reminiscent of Persian miniature painting.

Sultanabad became famous in the 14th century for pottery decorated in underglaze blue.

Green lustre was also produced there.

Apart from the use of ceramics for containers and utensils for domestic use, ceramics were used to great effect for decorative purposes, both internally and externally on architecture. Tiles in various shapes and sizes decorated in many of the techniques mentioned were produced over a long period and were popular in most Islamic countries, but especially Persia.

In the 16th and 17th centuries a number of the early ideas were revived especially at Isfahan during the reign of Shah Abbas. Lustre ware was again produced and is noted for its peculiar metallic reflections which contrast with the earlier lustre ware. Shah Abbas was so enamoured with ceramics, especially porcelain and Chinese ceramics, that he brought three hundred potters, together

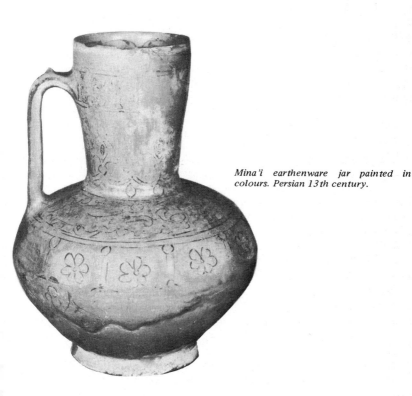

Mina'i earthenware jar painted in colours. Persian 13th century.

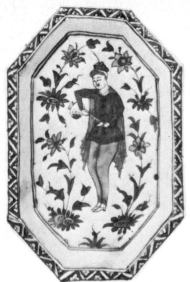

Left: Ceramic octagonal tray, painted in blue with a man pouring wine from a decanter surrounded by flowers. Persian 16th to 17th century.

Below: Persian turquoise blue glazed ceramic lion, seated on its haunches with its head slightly lowered. 13th century.

with their families from China to Persia. He hoped that they would teach Persian potters their craft so that porcelain equal to Chinese, could be produced in Persia. A number of examples of pottery of this period are so "Chinese" that the Dutch exported Persian blue and white to Europe as Chinese!

In Syria, the most important centre for pottery was Raqqa which was situated on the borders of Syria and Mesopotamia. It had close links with Persia, and much of its pottery was modelled on the Persian, in particular the blue and black ware and lustre ware. Barbotine ware was also produced. It is, however, difficult to distinguish Raqqa pottery from that of Egypt or other parts of Syria, for the style was not distinctive. As with Persian and other Islamic pottery, Chinese influence is noticeable, however, in general with some exceptions Syrian pottery is not distinguished by its unique nature, its potters producing wares similar to Egypt, Persia and Mesopotamia.

In Turkey, the true genius of the Turkish pottery does not manifest itself until the 16th and 17th centuries, when a superb form of polychrome white ware was produced at Isnik (Nicaea). The fabric was usually a fine white paste with designs outlined in black and painted in blue, aubergine, tomato red, green and lilac, the whole covered in a transparent glaze. Both vessels and tiles were produced, which were exported to a large area. The designs are mainly floral and extremely rich and naturalistic, the vivid colouring employed on some vessels producing a dazzling kaleidoscope of colours.

There are basically three kinds of Isnik ware which can be divided into early (1490-1525), middle (1525-1535) and late (1550 - c. 1700). The early wares are distinguished by a preference for blue and white decoration but the shapes are somewhat restricted following metal prototypes, and the glazes thin and fine. The middle phase, sometimes known as the Damascus style, after an erroneous association with that city, is notable principally for its larger palette, a green and several additional shades of blue being added to the blue and white. Favourite motifs include palmettes with small flowers, especially tulips, carnations and blue bells. Occasionally the artist has painted in an original manner, but generally the feeling is distinctly Chinese. Late Isnik, sometimes called Rhodian, again erroneously as Rhodes was never a centre of manufacture, is distinctive for its use of tomato red which when used under the glaze, a technique which is again distinctive of the period, stands up in relief. There is also an increase in the palette. Tulips now become an extremely popular motif. Some shapes are distinctive to Isnik, particularly the tankard. Around

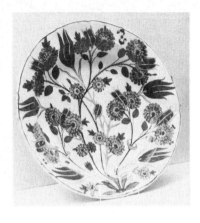

Floral Isnik dish painted in blue green. Turkey 1520–50.

1724 a factory was established at Istanbul where work continued in the old Isnik style. Later in the 18th century fine work was produced at Kutahya. The designs were usually outlined in a rather fussy manner and bright yellow became a popular addition to the palette, By the 19th century the golden age of Isnik had passed and designs of trees, boats, mosques etc. became popular, which although charming in no way compare with the early achievements of the Isnik potters.

Isnik bowl in underglaze blue, Turkish about 1500.

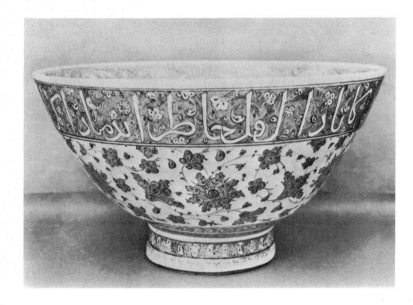

Last but not least amongst Islamic pottery are the superb ceramics of Islamic Spain. Although Spain had come under the influence of Islam at an early date, the pottery did not match the brilliance of other Islamic countries until about the 14th century, when the superb lustre ware made at Malagar became renowned. Lustre, first perfected in Egypt, manufactured in Persia, Mesopotamia and Syria reached a new brilliance in Spain. Most famous of the Malagar vessels now surviving is a huge decorative vase in the Alhambra at Granada.

Enamelled buff coloured earthenware drug vase painted in blue. Hispano Moresque (Catalan). Late 15th or early 16th century.

Tin glazed earthenware tile bearing the arms of the Nasrid Rulers of Granada. Spanish 1st half of the 16th century.

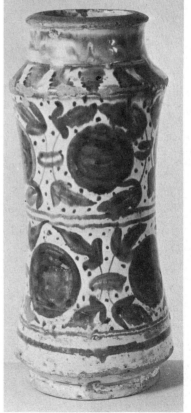

The harassment of the export trade from Malagar by Christian naval vessels, prompted some of the Moorish potters to move northwards towards Christian Valencia. Here they carried on their trade at first producing relatively simple pottery decorated in blue and green or purple and green. However, after 1400 the kilns at Manises were producing fine lustre ware. The early pottery continued to have the strong Islamic influence of Malagar, but soon mixed with the artistic motifs of Christian Europe to produce a unique blend. Throughout Hispano Moresque pottery, no matter how strong the Christian influence the mark of Islam is clearly visible.

Dish painted in copper lustre and blue with the arms of the Cabrera family of Catalonia. Spanish (Manises). 1st half of the 15th century.

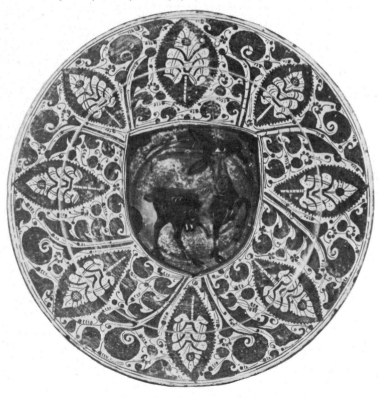

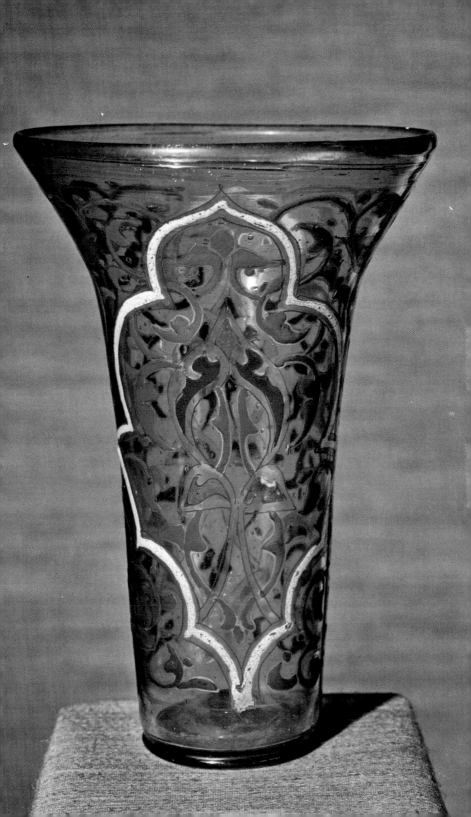

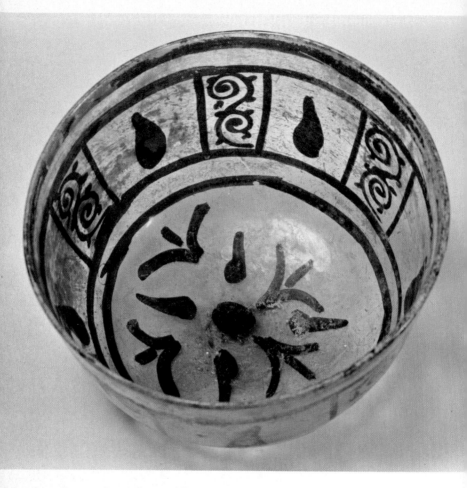

Lustre painted glass bowl. Egypt 10th-11th century.

Overleaf: Syrian gilt and enamelled glass beaker known as the "Luck of Edenhall" beaker. Probably made at Allepo c. 1240.

Right: Gilt and enamelled glass mosque lamp. Saracenic, 13th century.

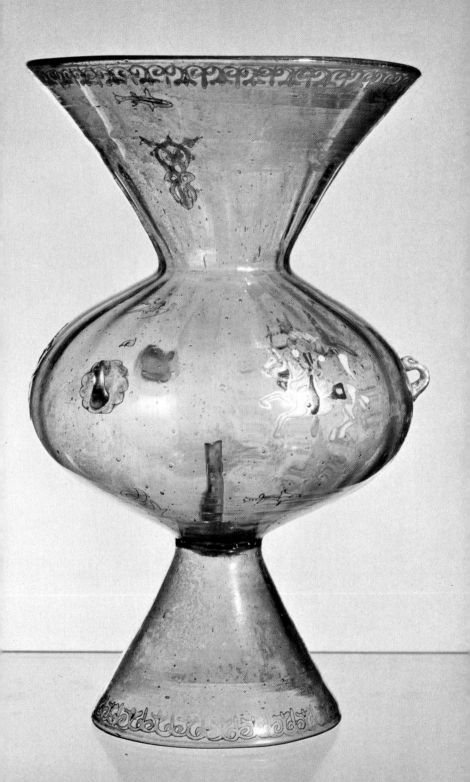

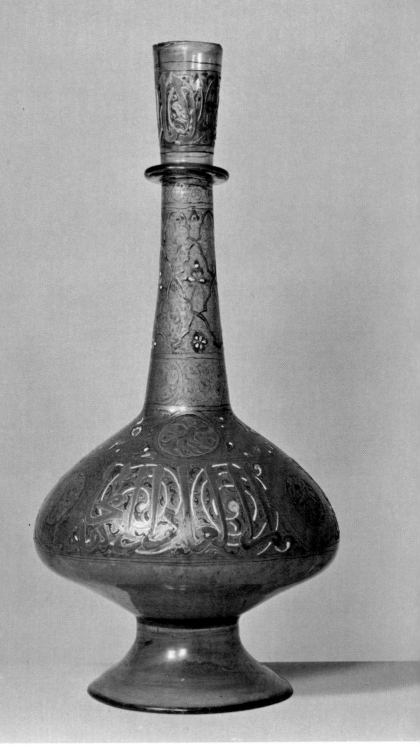

Long-necked Syrian enamelled and gilded glass bottle with an inscription in Kufic lettering in praise of an unknown sultan. End of the 13th century.

5 MASTERPIECES OF GLASS

Islamic glass owes as much to pre-Islamic traditions as it does to Islam. In the 7th century, marching under the banner of Islam, the Arab armies conquered Egypt, Mesopotamia, Syria and Persia, countries which had a tradition of glass making extending back to Roman and pre-Roman times. Although the Umayyads established the seat of their Arab empire in the former Byzantine province of Syria, a centre of ancient glass making, there are few examples of Islamic glass which can be dated to this period. Those that can are utilitarian in nature and continued the artistic traditions of earlier times. It was not until the mid 8th century that glass with a truly Islamic flavour was created. Until then, the old pre-Islamic traditions continued with little change.

Under Islam, many of the old traditions continued while at the same time new techniques and innovations especially of a decorative nature were introduced. The pre-Roman Egyptian technique of combed glass continued to be used for a number of objects. In this technique, coloured glass threads were embedded into the glass object and combed into attractive and colourful patterns while the object was still hot. The early Islamic artisans also produced vessels by mould blowing and casting, and decorated their glass ware by the ancient techniques of

Clear colourless glass goblet with thread decoration and prunts of self coloured and green glass. Persian, probably 10th to 12th century.

trailing and stamping. Excavations at Samarra, near Baghdad, the residence of the Abbasid caliphs from A.D. 833-883 brought to light a variety of glass vessels decorated in a number of techniques, including mould blown and cut vessels, the latter decorated with linear, facet and relief motifs. These vessels together with vessels and fragments from other sites in the Islamic world indicate that a number of techniques were in use. The technique of wheel cutting appears to have been a revival of Sassanian traditions. Apart from the wheel-

93

cut glass of Mesopotamia excavations at Nishapur, in Eastern Persia and Samarkand in Transoxiana indicate that wheel-cut glass was produced under the Samanids (A.D. 819-1004). A distinctive style of cutting, known as bevelled, can be recognised for its unusual method of cutting the outline of the design on a slant and for the absence of background detail on a second plane. The technique, which originated in Mesopotamia spread to Persia, Egypt and North Africa.

The technique of relief carving, the design of which is formed by cutting away the entire outer surface of the vessel except for the design, was used to great effect and resulted in some gorgeous examples of glassware. This form of decoration was popular in Mesopotamia, Egypt and Persia. Although extremely effective on glass, it may have originally evolved from the technique of carving hardstones practised in Persia and Mesopotamia. It is a relatively early Islamic technique, the first examples dating to about the 9th century. Beakers were often decorated in this way and some with wafer thin walls are masterpieces, not only of the artistry but

 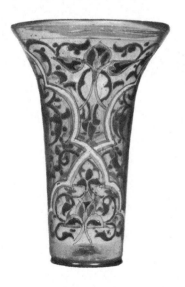

Left: Glass beaker, Egypt 13th century. Below: The 'Luck of Edenhall' beaker of enamelled and gilt glass. Syrian (probably from Allepo) c.1240.

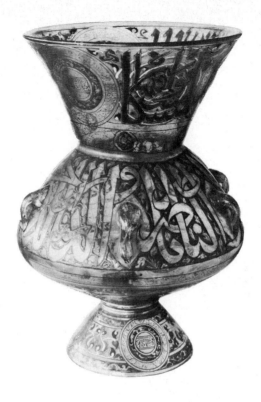

Glass mosque lamp. Syrian or Egyptian. 14th century.

also of technology, for considerable skill was necessary in order to grind the glass to a point of such high relief. This technique was employed to great effect on cameo glass, a method in which the glass base form was overlaid with glass of another colour (usually blue or green), the overlay then being ground away to leave a coloured relief design. Vessels of this kind are extremely rare, but a few have been found in Egypt and Persia, and a few fragments from the excavations at Samarra. The technique of cameo glass is not peculiar to Islamic

countries, it was practised to great effect by the Romans. The most famous example of this type of glass working is the Portland Vase. However Islamic cameo is crude and less controlled than the classical examples and the detail of the coloured relief which is linear rather than sculptural is wheel-cut through to the base colour.

The technique of lustre painted glass has already been mentioned in connection with ceramics. The metallic lustre which occasionally appears in polychrome is so fine that it can be seen but not felt.

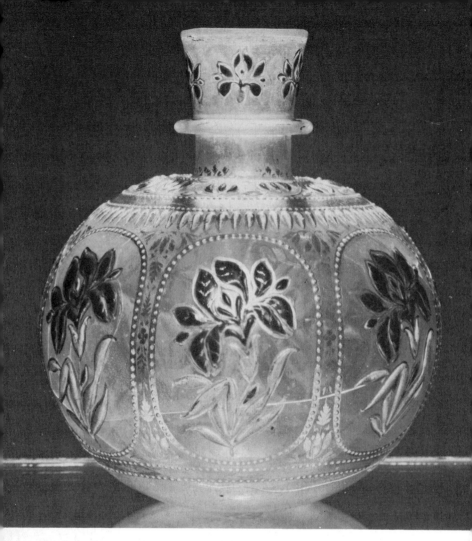

Gilt glass hookha bowl. Moghul, India 18th century.

Some of the finest examples of early lustre were made in Egypt. A related technique was that of gilding, the gold being applied to the glass vessel in suspension, and then fired. The technique was popular under the Seljuks.

Islamic glass reached its zenith under the Mamluks when the preceding techniques of gilding was combined with opaque vitreous enamels to produce wondrous works of art. It was a marriage of two techniques and traditions, the technique of enamelling developed in Syria possibly at Raqqa, and that of gilding which may originally have been developed in Egypt.

Islamic enamelled and gilded glass can be divided into groups, which, with the exception of the

Fustat group which were made in Egypt between 1270-1340, were all made in Syria.

The division into groups has been made on the basis of artistic evidence of style and technique, and that of history but has not as yet been supported by archaeological evidence. The Syrian groups have been divided as follows:

a) The Raqqa group - circa 1170-1270 A.D.
b) The so called Syrio-Frankish group circa 1260-1290.
c) The Aleppo group 1250-1265.
d) The Damascus group 1250-1300.
e) The so called Chinese group 1285-1400, named after the "Chinese" decorative elements introduced by the Mongol dynasty in Persia and Mesopotamia.

The finest examples of vessels of the gilded and enamelled technique are the superb mosque lamps. These lamps, which appear more like vases when seen in museum cases, were in fact meant to be suspended from a ceiling. When viewed from beneath the flickering light from within would reveal the exquisite design in a kaleidoscope of colour. An inscription from the Koran usually encircles the neck of the lamp while the waist sometimes is inscribed with titles of the reigning Sultan. A popular Koranic verse used on the lamps was taken from the Chapter of Light in which Allah is compared to a radiant

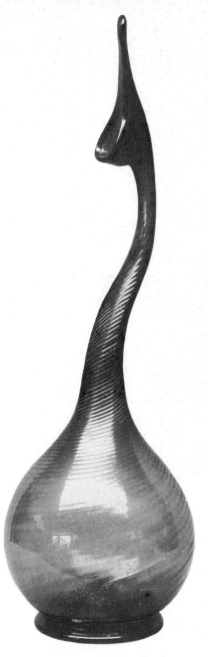

Green glass perfume sprinkler. Persian, 16th or 17th century.

97

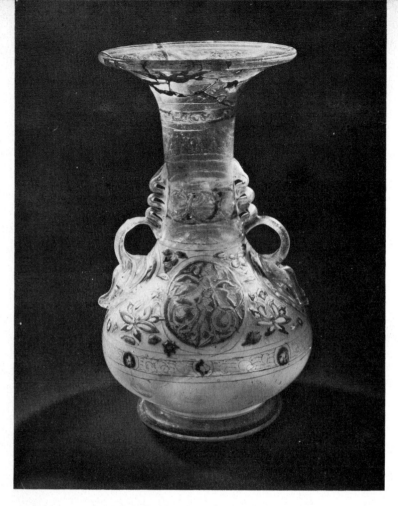

Mamluk glass vase with applied pinched loop handles, the shoulders enamelled with blue, white, emerald and yellow flowers around royal blue and gold medallions. Egypt, late 14th century.

universal lamp. In the Koran the light of Allah is described as "a niche in which is a lamp, the lamp is in a glass, and the glass is as it were a brightly shining star".

In the 15th century, the Syrian glass industry received a blow from which it apparently never recovered. Timur captured Damascus and transported the cream of its craftsmen including the glass workers, to his capital at Samarkand where he hoped to establish a glass working tradition in Transoxiana. This had such a serious effect on the Syrian artisans continuing the tradition of enamelled glass and manufacturing mosque lamps for patrons in the Near East. Thus we see Islamic traditions and techniques passing to Europe.

In Persia under Shah Abbas (1587-1628) the glass industry which had been dormant for some three centuries was revived, the

old techniques returning from Italy. Glass of this period strongly resembles the glass of Renaissance and Baroque Venice. The finest examples were made at Shiraz, although glass was also worked at Isfahan, though the latter was of inferior quality.

The glass industry of Moghul India appears to have originated from the Persian tradition. The early vessels of the 16th century may in fact be Persian imports and it is not until the 17th century that identifiable Indian glass ware makes its appearance. The techniques employed by the Indian craftsman were similar to those employed on rock crystal and included wheel-cutting, incrustation with jewels, as well as gilding and enamelling.

The decorative motifs employed on the early Islamic glass are similar to those on the pottery in that they are mainly geometric, both abstract and floral, including the arabesque. The arabesque is perhaps the most distinctive element of Islamic art. Basically it consists of a rhythmic pattern of vegetative tendrils with leaves and petals, arranged in an infinite variety of geometric forms. Invented and developed during the early days of Islam it continued in use and is found as an important decorative element on Islamic art of all kinds at all periods. Later, figurative motifs, both animal and human, make their appearance, while during the Mamluk period especially, calligraphy is prominent. Moghul motifs are mainly floral. The glass of Moghul India are the last glass treasures of Islam, the final expression of a once vibrant art.

Enamelled glass bottle. Syrian about 1250 - 60.

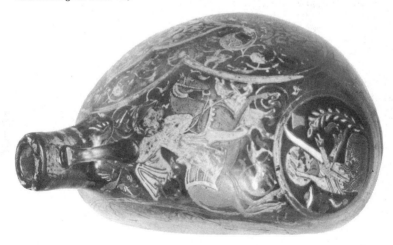

99

6 PRECIOUS METALS

There are probably more master-pieces of metalwork amongst the treasures of Islam than any other form of art. Certainly there is little doubt that metalwork is the most continuous and best docu-mented source of the history of art throughout the Islamic world from about the 12th century to the end of the 14th century.

The superb quality of Islamic metalwork is probably due to the magnificent pre-Islamic metal-work tradition of Sassanian Persia, which produced some of the finest examples of metal craft in the post Roman world. This tradition, combined with the metalworking traditions which existed in Syria, Egypt and Byzantium responsible for some of the finest ancient masterpieces of the pre-Islamic world, greatly influenced the metalworking techniques of the early days of Islam and had a lasting effect on Islamic metalwork over many centuries. The ancient techniques employed by the Sassanians especially, were continued and employed to great effect by the later artists and craftsmen. This Sassanian influence can be seen not only in the subjects used to decorate some of the early metal-work, but also in some of the techniques employed in their manufacture.

Bronze lamp stand. Egypt, 8th century.

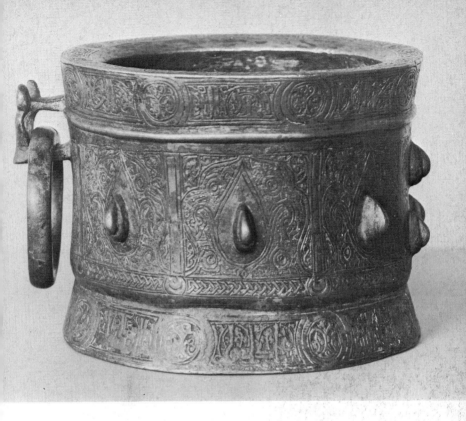

Persian bronze mortar engraved with a design of inscriptions and other motifs.
10th/11th century.

The metalwork of the Umayyad period (661-750 A.D.) is extremely rare, with few attributable items of the period known, those that are being mainly in Russian museums, having been traded at an early date for furs. The Buyids (932-1055 A.D.), one of the Persian dynasties which along with the Samanids (874-999 A.D.) were the most powerful of the indigenous dynasties which attained power in the 10th century after the decline of the Baghdad caliphate, are especially noted for their metalwork. The Buyids controlled South Persia and Transoxiana. Much of their metalwork shows every influence of Sassanian tradition, but the decorative style is different. Apart from the superb linear art which adorns much of Islamic metalwork the historical value lies in the innumerable inscriptions and dedications which many of the vessels bear. Much of the Buyid metalwork, especially gold and silver is in the Hermitage Museum, Leningrad. A notable example is a gold jug in the Kevorkian collection which is inscribed in Kufic with the name of Abu

North Mesopotamian brass damascened ring stand with a valedictory inscription in figurative Kufic in silver. Mosul 12th century.

times the entire body takes the form of an animal, which could be considered the prototype of the medieval aqua maniel. The Sassanian tradition of using animal forms for the bodies of the vessels, such as the ewer and also the candlestick continued to be popular especially in the 12th century.

Many examples of Samanid metalwork, a number of which are of precious metal, are also in Russian museums. Thirteen superb pieces of silver treasure dating to the 10th century in the Gulistan museum, Tehran, are engraved and nielloed with inscriptions, seven of which bear the title of Amir Abu'l-Abbas Walkin ibn Harun, who lived in Azerbaijan in 957.

Mansur Bakhtiyar a member of the Buyid dynasty, centred at Baghdad, who died in 978. This exquisite vessel is decorated in low relief with the design in the Sassanian tradition of rams and winged creatures.

A vessel popular from about the 7th to 10th centuries is the bronze ewer, which had its origins in Sassanian prototypes. The early vessels with their elongated spouts and long slender handles are Hellenistic in form with the decoration in engraving or repoussé, Sassanian in inspiration. The spout usually protrudes from the body of the vessel and often takes the form of an animal which is repeated on the handle. Some-

North Mesopotamian inlaid brass ewer made at Mosul in 1232.

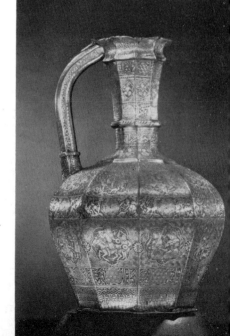

Much of the early Islamic bronze work bears a simple engraved decoration, the majority of the metal being left plain. Inlay is not generally found before the middle of the 12th century when silver, red copper and later gold were used to ornament bronze. Vessels engraved with linear designs consist mainly of arabesques, animal ornaments and Kufic inscriptions. The designs are often extremely complicated, which when the object was new and highly polished must have been exceedingly beautiful. Gradually, however, a more elaborate form of decoration was developed employing inlay. This was used to great effect on dishes, candlesticks, ewers, writing cases, mortars, basins, astronomical instruments and other things.

Persian brass bowl engraved and inlaid with copper. 12th century.

In the 11th century a Central Asian people, the Seljuk Turks overthrew the indigenous Persian dynasties and established themselves in Iran and Anatolia, occupying Baghdad in 1055. There are few examples of Seljuk precious metalwork in the West, the majority being in Russian museums especially the Hermitage Museum in Leningrad. More common is Seljuk bronze work much of which is richly inlaid with silver. Perhaps the most famous of silver inlaid bronzes, the Bobrinski bucket, is again in the Hermitage Museum. This superb work of art was made in Herat in 1163 cast by Muhammad ibn Abd al-Wahid and inlaid by Masud ibn Ahmad. It is exquisitely inlaid in gold, silver and copper with elaborate abstract figurative and calligraphic designs. Although made for a rich merchant, it has an air of opulence and style usually associated with nobility. The figurative motifs depict the courtly

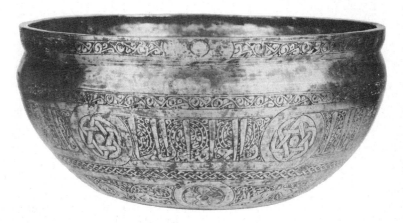

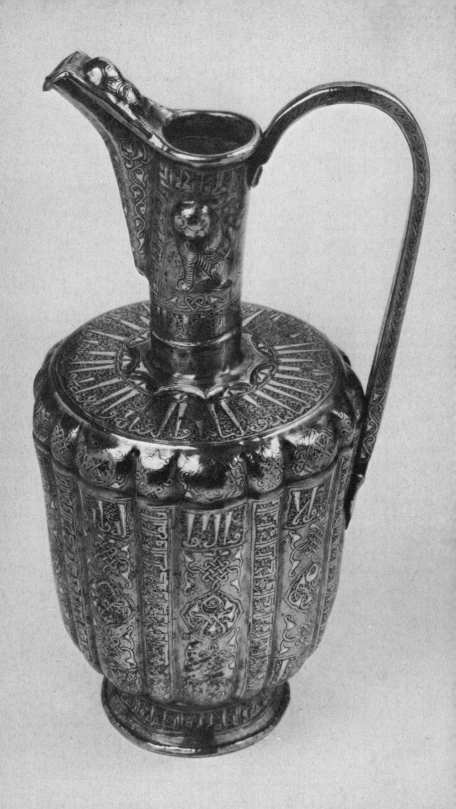

pursuits of hunting, drinking and sporting. Three bands of elaborate calligraphy adorn the vessel, the uppermost being a marriage of both calligraphy and figurative decoration with figures sprouting from the tops of letters. The middle band is elaborately plaited.

The popularity of figurative art in Seljuk times is reflected in the pottery figurines and metal incense burners in the form of animals and humans, as well as on the façades of buildings. Many of these figurative objects can be more likened to sculpture than to vessels. They have form, balance and movement which places them amongst the highest forms of art. The bodies are rarely left plain and are usually decorated with elaborate incised and perforated floral and abstract designs, a merging of two dimensional design with three dimensional form. The ewer, candlestick and mortar continued to be made, while new objects such as the characteristic discoid weight with relief decoration usually of bird, animal or floral motif makes its appearance. While elaborate geometric patterns were favoured as decoration for large vessels, smaller objects such as the weights and personal items such as belts buckles and jewellery tended to be decorated with natural and mythical birds and animals. Excavations at Sistan, Khorasan and Nishapur in North East and East Persia and Rayy, Nihavand and Hamadan in Central and West

Persia have unearthed a number of metal objects including mortars, mirrors, bottles, incense burners, buckets, pen boxes and ewers. Metalwork from Central and Western Persia, however, is less plentiful, the main centres appearing to have been in North East Persia. The majority of these pieces are decorated with panels and friezes of animals, medallions with mythical animals such as sphinxes and griffins and also birds set onto a background of arabesques. Benedictory inscriptions are usually in Kufic or Naskhi.

The technique of inlay seems to have first been used to effect in East Persia at Khorasan. The earliest example being a bronze pen box dating to 1148 A.D. now

Bronze bowl and cover with remains of gold and silver inlay, Persia. about A.D. 1200.

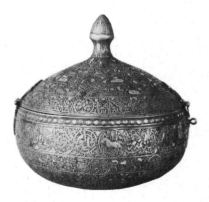

in the Hermitage Museum. The art of inlaying involved an elaborate technique. The design was first carved onto the bronze vessel in such a way that an anchor groove was undercut. Into this silver, gold or copper was inserted and burnished into position. Once the inlay was firmly anchored and smoothed to the contours of the vessel the inlay itself was engraved and chased. Occasionally blank spaces were filled with black mastic. The resulting effect was a rich metal brocade. Inlaid metalwork is without doubt one of the greatest arts of Islam.

Under the Mongols, Seljuk traditions continued but somewhat modified by Far Eastern influence. The major metalworking centres of the Seljuks were sacked by Genghis Khan in 1220, but the craftsmen were transported to Mongol centres such as Karakorum where they continued to produce bronzes. Occasionally Chinese influence can be seen in a variation of inlay technique; the introduction of thin, deep inlay of silver.

Under the Timurids, Persian metalwork continued without interruption. A change of style is,

Brass writing box damascened in silver and gold with a design of arabesques and rosettes; and an inscription. Syria, late 13th century.

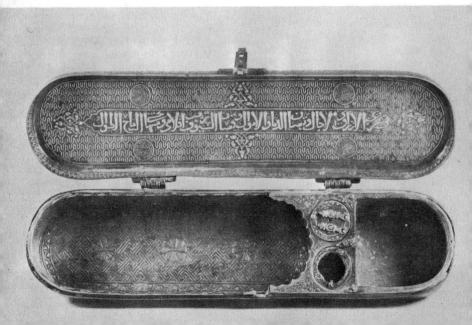

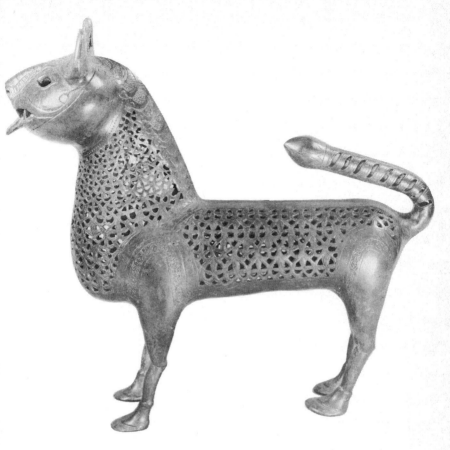

Bronze incense burned in the form of a lion. Persia, 12th century.

however, noticeable. Figures, when present are more elegant and graceful and inscriptions tend to be in Naskhi, both expressing indigenous Persian culture rather than Arab. Timurid metalwork is the last expression of medieval Islamic tradition.

Very little is known of Persian metalwork of the 15th century. Much of the gold and silver vessels seem to have been melted down for bullion. Among the objects that have survived are some fine silver, parcel gilt and jewel encrusted vessels, captured by Sultan Selim from Shah Ismail in 1514, now in the Topkapi Museum in Istanbul.

Under the Safavids, indigenous Persian ideas are predominant. The animal and figurative motifs are still present, but are more realistic and sensuous. The designs tend to be more finicky and delicate in contrast to the earlier boldness. Patterns tend to be of a smaller scale and the earlier

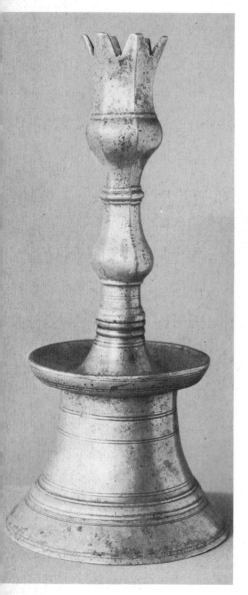

practice of including patterns in bands is no longer found, with perhaps the exception of inscriptions on the base, foot or rim of the vessel. The fine engraving tends to cover the entire surface, occasionally with the inscriptions set in cartouches. In the 17th and 18th centuries the designs tend to be rather stiff and laboured losing all their earlier vigour. Niello work occasionally relieves the design from becoming stereotyped. Many of the copper vessels were tinned to simulate silver. Some of the finest metalwork of the period was not in bronze or copper, but in steel. Because of its nature much steel metalwork seems to be related to arms and armour, although some astronomical and other instruments were also made. The steel is carved, sometimes deeply, with designs of arabesques and other motifs, and is sometimes inlaid with gold.

In Mesopotamia, little of the early metalwork either in precious metal or bronze has survived, although it must have been fairly plentiful as there are copper mines in Arghana in the watershed of the Tigris and Euphrates. Perhaps the finest surviving example is a superb bronze cloisonneé enamel plate dating to the 12th century made for Urtukid Rukn al Dawla Dawud (1108-1145). This exquisite plate is decorated in polychrome with birds, animals and figures with the main scene of a throned figure surrounded by dancers. The use of cloisonneé

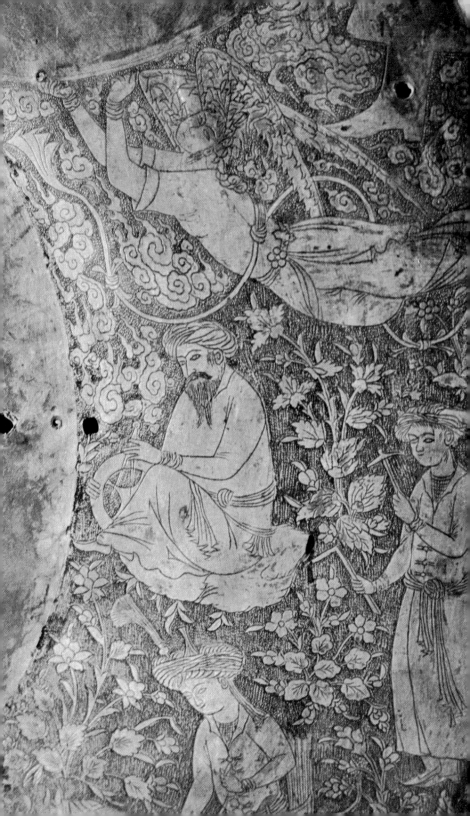

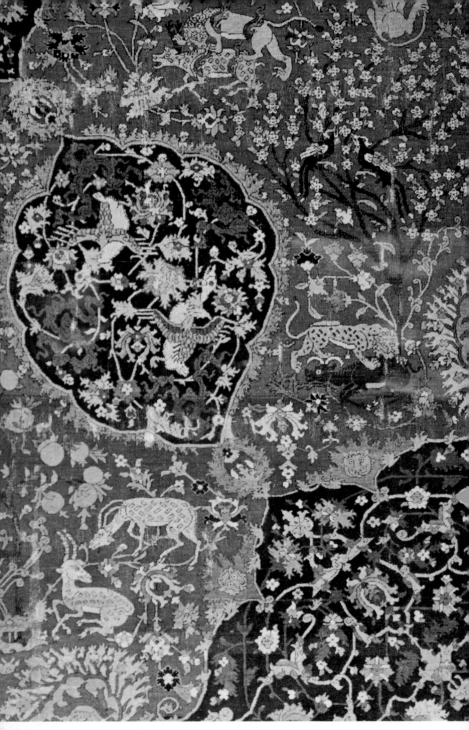

Detail of a Persian carpet known as the "Chelsea carpet". Knotted wool 16th century.

Overleaf: Detail of fine engraving of a zodiacal design on a large brass astronomical instrument. 17th century.

Right: Detail of a fine Persian textile. 17th century.

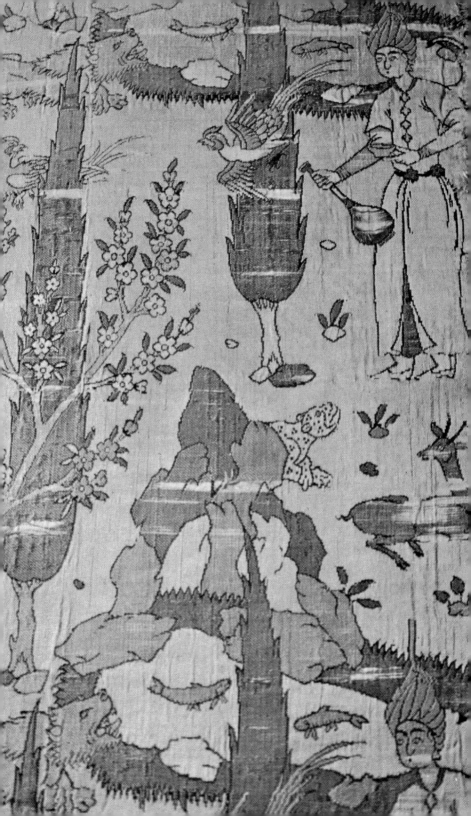

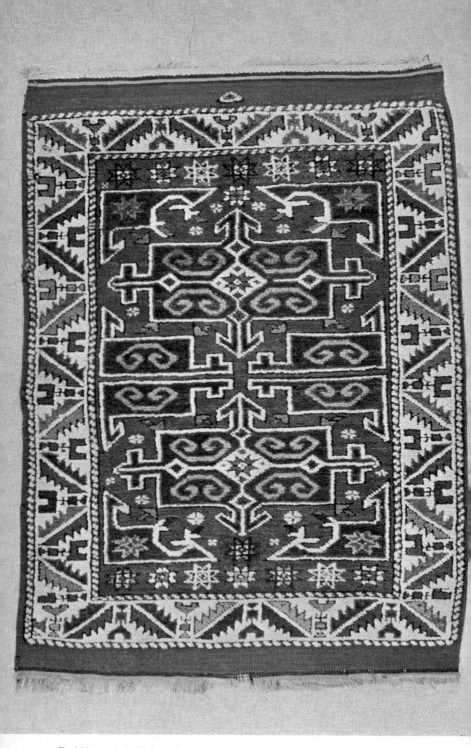

Turkish rug, late 18th century.

enamel seems to be Persian in origin while the design shows a strong influence by Byzantine traditions, though the plate was probably made in Mosul. There is little of Islamic traditions visible in the plate. More Islamic and certainly more typical is an inlaid ewer in the British Museum, which dates from 1232 signed "made by Shuja ibn Mana of Mosul". There does not appear to be any evidence of inlaid metalwork being made in Mesopotamia before the 13th century, when a fully fledged industry suddenly appeared. The ewer is distinctly Mesopotamian in design in spite of an overall similarity to Persian ewers. The body is completely covered in engraving of tight arabesques and angular designs which surround medallions containing figurative scenes. There are bands of animated script as well as a central running frieze round the bulbous body. The "animated" inscription is more elaborate and fantastic than the Persian.

Zodiacal motifs were as popular with the Mosul artists as they were with the Persian. Another design employed in Persia and also found in Mosul metalwork is the seven dot rosette. The survival of a number of North Mesopotamia as a centre of the Mongols a number of metal craftsmen from Mosul joined their Persian counterparts at Karakorum and other centres but in spite of this Mosul continued to produce

Brass food box. Egypt, Mamluk period.

113

metalwork until the 14th century.

It is often difficult to separate the metalwork of Mosul from that of Damascus, in fact separation in many cases can only be made on the basis of signature and inscriptions rather than style. However, a notable distinction of the figurative designs on the metalwork of the Ayyubids, who controlled Egypt and Syria from 1168 to 1250, is the attention to facial detail which gives the figures a certain individuality. Some of the finest of all Islamic metalwork was produced under the Ayyubids who developed the tradition of rich inlay to such a degree that the entire surface and many times the interior of the vessel (especially of bowls and basins) was covered with the most exquisite designs. Some of the Ayyubid metalwork is decorated with Christian subjects and figures. These vessels were made as gifts for the Christian kingdoms of Syria, a reflection of the friendly relations that existed between the Christian kingdoms of Syria and the Ayyubids. The increasing use of figurative motifs, especially of a large size, is noticeable.

In Egypt under the Fatimids (969-1171 A.D.) there appears to have been a rich tradition of metalworking but little or nothing has survived. That superb gold and silver work existed is indicated by an inscription by Nasir-i-Khusrau who wrote of the luxurious gold and silver work after an inspection of the state apartments in 1047. A

Brass bowl signed "The work of Turanshah." Made for Muhammad ibn Abdullah al-Khurkam. Persia, dated A.D. 1351 (1752 A.H.)

magnificent silver gilt casket now in the cathedral of Gerona testifies to the fantastic metalwork that must have existed in Fatimid Egypt. The casket was made under Fatimid influence for Hisham the caliph of Cordoba, when heir apparent. Coptic influence can be seen in many of the early bronzes and in particular the popular type of standing lamp. Both engraved and cast bronzes were produced as well as sculptural figurative pieces in the form of animals. The bronzes of

the succeeding Ayyubid period have already been mentioned, the style of Egypt being similar to that of Syria. The earliest dated inlaid metalwork attributable to Cairo is an astrolabe made in 1236 by 'Abd al Karim. This superb instrument is inlaid in silver on both the front and back with both a figurative and vegetative design and is probably the finest in existence.

Fine bronze work continued to be made under the Mamluks (1252-1517 A.D.) who in 1250

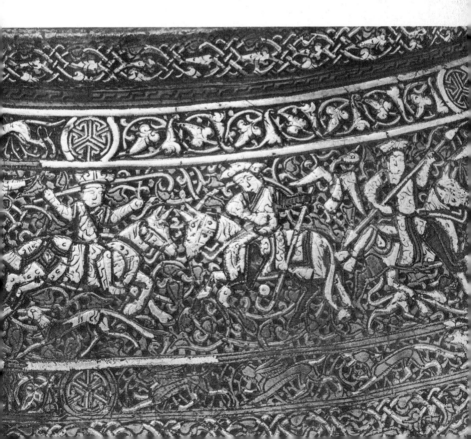

Above: Mesopotamian bronze candlestick damascened in silver. Mosul 13th century.

Bowl in the form of a dervish's wallet, in watered steel chased and engraved. Signed Haji Abbas. Persia (Isfahan) 19th century.

seized power from the Ayyubids Perhaps the finest piece of Mamluk metalwork to survive is the baptistère de St. Louis by craftsman Muhammad ibn al-Zayn. A superb object now in the Louvre is the very epitome of the best Mamluk craftsmanship. Many of the metalworkers of Damascus were taken to Samarkand after the sack of Damascus by Timur in 1401.

During the 14th century a number of Far Eastern designs made their appearance especially the Chinese lotus.. These designs were probably taken from Chinese textiles and porcelain many fragments of which have been found in excavations in Egypt.

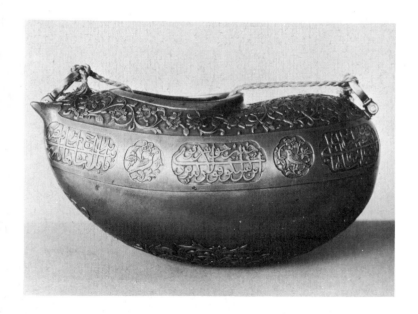

Fine metalwork continued to be produced until the beginning of the 15th century when quality deteriorated simultaneously to the quantity produced. It is possible that the decline may be attributed to Chinese blue and white porcelain which was being imported in large quantities throughout the Near East.

The 15th century saw the decline of Egyptian domestic metalwork which was replaced by superb inlaid steel work, but the art is no longer that of the metalsmith but that of the armourer. The true genius of Islamic metalwork, however, continued in Persia where it had its origins, until the 18th century when the Afghans invaded Persia and destroyed Shah Husaya, the last of the Safavids. The end of the Safavids marked also the end of a long period of superb creations in metal, the like of which was not seen in any other part of the world.

Brass falconer's kettle drum, engraved with verses. Persian, 17th century.

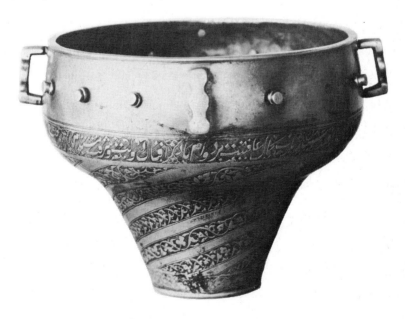

117

7 SILKS BROCADES AND MAGIC CARPETS

Perhaps the most familiar of all Islamic arts is the rug or carpet. They are also perhaps the most perfect expression of the Islamic ideal of art, the infinite pattern. A true art of Islam they reflect the life and culture of the peoples of the Islamic world from the earliest times. The arts of carpet weaving and textiles are intimately related, rugs and carpets being an essential element of Islamic interior decoration, both of the tent and of the building. They embody all forms of Islamic art, geometric figurative, floral and arabesque.

Textiles too reflected the popular artistic taste of the day. Excavations at Samarra in Mesopotamia have revealed some of the earliest examples of Islamic

Right: Embroidered cover in silk on cotton in double running stitch. Persian dated 1793.

Below: Diasprum, brown silk and gold and metal thread. Mesopotamian, early 11th century.

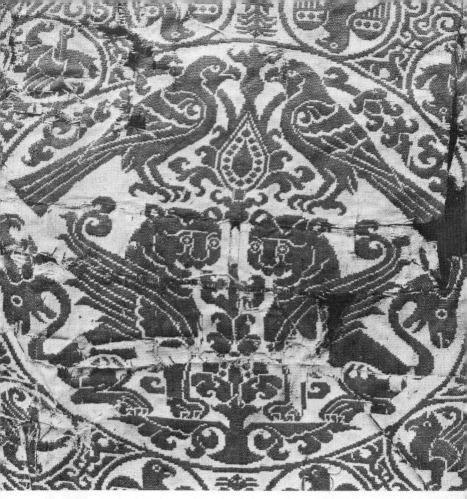

Silk tissue, double cloth with plain tie, found near Rayy. Persian (Seljuk) 11th to 12th century.

textiles, beautiful fragments of woven silks dating to about the 10th century, the designs of which are found reproduced on the wall paintings of the palace. As with metalwork, Sassanian influence can be clearly seen. A fine example of mid 10th century silk textile from St Josse-sur-Mer, looks distinctly Sassanian, but for the distinctive Kufic inscription which states that it was made in

Khorasan. However the style was in a state of flux, and by the 11th century the new styles of the Seljuks had firmly established itself. The transition from one style to another can clearly be seen in a collection of silks found at Rayy. The change is distinct but subtle. The Sassanian practice of using horizontal rows of motifs and roundels are retained, but there is a fineness of detail absent

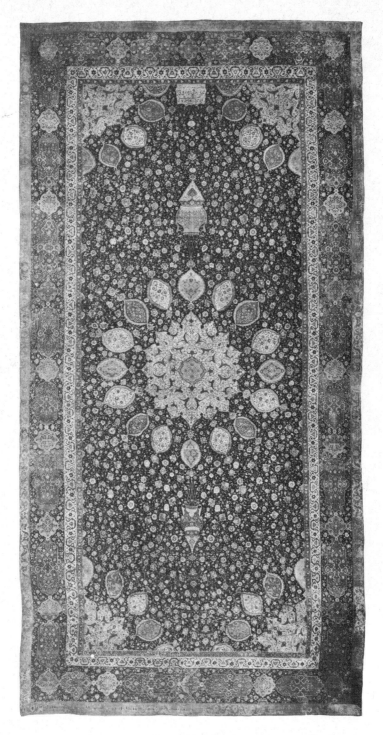

120

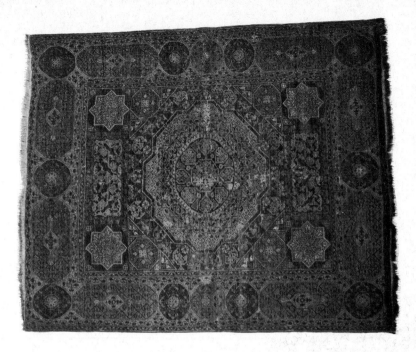

Carpet from the Cairo workshops. Egypt 16th century.

in the earlier textiles. The degree of fineness of Seljuk textiles has never been surpassed but the impact of the design is not as great as their Sassanian prototypes. Another centre of the Persian textile industry known to have been producing textiles in the 12th century was Soghdia. Silks with pairs of facing stylised birds and animals are known to have been made there.

Left: The Ardabil carpet. Persian dated 1540.

During the 14th and 15th centuries a new style developed with the old orderly pattern being discarded in favour of a scrolling design. The same style is also found in Egypt and Mesopotamia and has a distinct Chinese influence. It is difficult to ascribe with certainty any surviving textiles of this kind to Persia, although the motifs are also seen on ceramics and manuscripts. Textiles of this type had a great influence on the early European fabrics, especially Italian.

There is little doubt that the finest and most exquisite textiles were made in Persia under the Safavids (1502-1736). The textiles

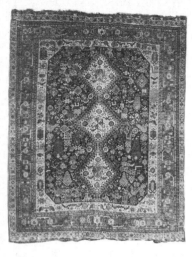

Above: Persian carpet. 19th century.

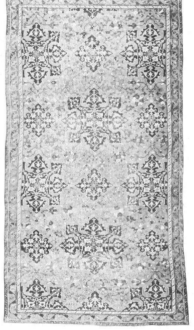

*Right: "Star Ushak" carpet. 1st half of
the 17th century.*

Below: 19th century Shirvan rug.

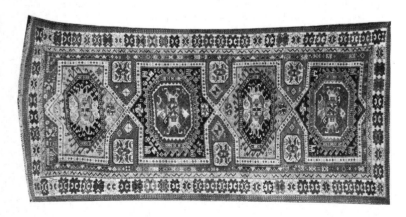

were probably produced in order to meet the demand of an era in which prosperity and luxury were the norm. Superb velvets were made with glorious figured designs, more reminiscent of miniature paintings than textile designs. Decorative subjects of the 16th and 17th centuries were drawn from animals and flowers, the most popular being the tulip, rose, hyacinth and iris, and the leopard, hare and gazelle. Many of the legendary themes illustrated in Persian miniature paintings were also favourite subjects for textiles. Gold and silver were combined with a variety of wonderful colours to produce a gorgeous array of rich and vibrant colour.

Towards the end of the 17th century the designs became less vibrant and more controlled and delicate, boldness being sacrificed to detail. Major centres for Persian textiles were Yazd, Rasht, Kashan and Isfahan.

In Egypt the ancient tradition of the textile industry was continued under the banner of Islam. The Egyptian weavers had a tradition extending back to Pharaonic times. The immediate predecessors of the first Egyptian Islamic textiles were Coptic, a fact which is more than hinted at in Egyptian early Islamic textiles. Both figurative and calligraphic designs play an important part in textiles of the Fatimid period. Inscriptions are particularly useful as they help to give firm dates to textiles which would otherwise be dated on stylistic grounds alone. The textiles of the Mamluks are less impressive, with the overall designs becoming smaller and more fussy. Inscriptions were still used. Embroidery seems to have taken precedence over the loom.

Not a great deal is known about the early Turkish textiles. The majority of examples which have survived to the present day belong to the Ottoman period (1300-1924). Magnificent fabrics of silk, velvet and brocade were produced for the Sultans, of a quality equal to that which must have originally been made for the Byzantine emperors, when the industry was in its infancy. The insatiable demand of the court for fabrics for their rich costumes must have almost drained the production centre of Bursa. Many of the floral motifs found on Isnik pottery are found woven in beautifully rich colours of blue, red, yellow, black and gold on blue, red and yellow backgrounds. Striped designs were also popular. In addition to their use in costume, textiles were also in great demand for interiors, as furniture coverings. The richness of a Turkish interior with its silks, brocades, velvets and magnificent carpets, must have been something to behold.

The Islamic taste for rich fabrics was introduced into Spain simultaneously with the religion. It is recorded that by the 9th/10th century there were as many as eight hundred looms working in

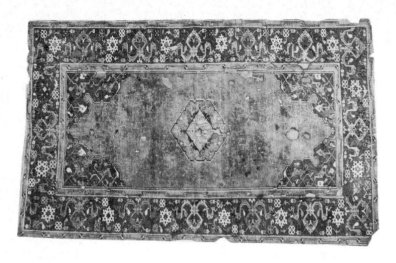

Turkish rug, knotted wool pile on woolen warps. 16th century.

Andalusia. Looms were set up in Seville, Almeria, Malaga, Granada, Alicante, Murcia and Balza. Because of the similarity in design, and the absence of an inscription or identifiable mark, Spanish textiles can easily be mistaken for Egyptian. Textiles continued to be important in Spain until in the 15th and 16th centuries their magnificence rivalled those of the eastern Islamic world. These later textiles with their dark backgrounds and light designs in cream, white, blue and red are easily recognisable. The motifs, usually from the animal kingdom, are somewhat stiff and formal. Fabrics of a similar nature were made in Sicily which had also fallen under Islamic domination. From about the 13th century Spain also produced textiles with predominantly geometric designs.

Later, the coarser fabrics were replaced by fine brocades, occasionally with European heraldic motifs (Mudejar style).

The art of carpet weaving in Islamic countries is extremely old. Excavations at Fustat in Egypt have uncovered fragments of early rugs, one of which can be dated to the year 821, and there is evidence that fine carpets were produced in the 11/12th centuries under the Seljuks. However, what can be termed the golden age of Islamic rugs and carpets did not start until the 16th century. There are three separate traditions, the Egyptian Mamluk, the Persian and the Turkish.

The Egyptian tradition, pre-Islamic in origin, utilised a beautiful colour combination of a burgundy red ground with the design worked in green and light blue. The design, which is divided into sections is principally geometric, usually consisting of primary motifs of stylised papyrus plants, rolled leaves and secondary

motifs of arabesques and interlaced ornaments. The entire rug is covered with motifs and because of the absence of a contrast between the border and the field, there appears to be little difference between the two. The Mamluk rug technique did not survive the downfall of the dynasty, the new Ottoman ideas displacing the old. At first there was a fusion of Mamluk and Ottoman ideas, but later Ottoman ideas became entirely dominant.

The most famous Islamic rugs, however, are those of Persia and Turkey. There is little documented history of the earliest Persian carpets and actual specimens are just as scarce. This is due to the perishable nature of a carpet which was meant to be used. Other Islamic arts such as pottery and metalwork were more durable and therefore stood a better chance of survival, while manuscripts and paintings would have been valued and therefore cared for. This is not to say that carpets were not cherished by the Persians themselves, on the contrary they were highly valued and held in great esteem, as they still are.

Although carpets were probably made in Persia over a thousand years ago, the earliest complete specimens that have survived appear only to date to the end of the 15th/16th centuries. An extremely beautiful and valuable specimen, not only from the artistic but also the historical point of view, in that it helps give us a dateable anchor, is the Ardabil carpet in the Victoria & Albert Museum, London. The carpet is dated AH 947, equivalent to 1540 A.D. and was made by Maksud al-Kashani in 1539-40 for the Shaykh Safi Shrine in Ardabil, by order of Shah Tahmasp. This superb carpet which measures 11.52 x 5.34 metres is woven in beautiful but sombre colours in an elaborate floral design. The large central medallion appears to be the underside of a typical Safavid dome of a mosque with two mosque lamps hanging, one to the right and one to the left, attempting an illusion of perspective.

Persian carpets vary enormously in size from those such as the massive Ardabil carpet to prayer rugs measuring a little over a metre square. They are normally long and rectangular rather than square and the colouring is deep and rich. The ground was usually indigo or crimson. Rich warm yellows, browns and greens were occasionally used while yellow although common has faded and today appears mostly as a neutral tint. The common material was wool with the warps being occasionally of cotton, however, a very special form of carpet employed a silk pile in place of wool. Even rarer are carpets incorporating gold and silver thread with the pile. Silk pile carpets were exported to Poland in the late 16th and early 17th centuries where they were very popular.

Thus they are known as Polish carpets. It is very difficult with carpets made before the 18th century to place them in their town of manufacture. Classification of old Persian carpets is more commonly made according to the style or design, "animal", "vase", "garden", "floral" or "medallion". Only later does it become possible to attribute them to certain towns, Sine, Farahana, Tabriz, Isfahan or Kashan. They are however distinguishable from Turkish rugs not only by differences in the design but also in the knot. The Gordes knot was used in Turkey, while the Sine knot was commonly used in Persia.

The majority of Persian carpet designs are based on floral motifs with occasional figurative designs both human and animal as well as a few simple geometric ones. The garden carpets are laid out either in the form of a plan of a garden with paths, flowerbeds, ponds etc., or, more generally clumps of flowers and plants. The age of the carpet will determine whether or not the floral arrangements are placed in regular networks. In the 17th century, the blossoms are large and conventional and the stems form an intricate network. While in the 18th century the tendril network becomes even more elaborate with the blossoms becoming mere rosettes. Animal carpets often portray hunting scenes, while medallion carpets employ a large central medallion

with lobed outline similar to the Ardabil carpet. The so-called vase carpets are a formalised form of floral carpet containing vases.

It has already been said that it is difficult to attribute carpets to particular centres, however, as a general rule the animal carpets may be said to have been made at Isfahan, the vase carpets at Joshaqan, the large medallion carpets being developed at Herat.

The other great tradition was that of Turkey. Early Turkish carpets still followed Seljuk inspiration utilising angular patterns but were soon replaced by designs of stylised animal and birds. The "animal" carpets of Turkey are quite different to the Persian in that they show a strong Turkish element. The oldest Turkish Ottoman rug is dated 1584 and was probably made at Ushak. The regions associated with Turkish rug making, Ushak, Gordes, Bergama, Kula, Kirsehira, and Ladik each had their own individual design and colour scheme. The rugs, which follow the indigenous tradition of Ushak, have designs of rows of large stars filled with abstract arabesques or flowers in yellow or white on a deep blue base, surrounded by a white outline contrasting on the superb Anatolian red ground of the carpet. Another medallion pattern was its Persian cousin.

The Turkish rug industry was a peasant occupation of the countryside rather than in factories under the direct patronage of a Sultan.

The large carpets so popular in Persia was less so in Turkey. Rugs were made with the same materials as the Persian, wool and cotton, and occasionally with the use of silk. Designs are often nicknames or trade names. The so-called "Holbein carpets", the "classical" Turkish rugs have designs of rows of staggered polygons formed of interlaced arabesques. Another popular design is the so-called "bird design" which although it has the appearance of birds it is in fact floral.

A peculiar form of carpets with severe geometric designs were made in the region between Persia and Turkey and are known as Caucasian.

The final expression of Islamic genius in carpets and rugs appeared in India. The carpets were based originally on Persian models but soon developed a typical style of their own to suit the tastes of the Moghul emperors. The colours are distinctive and are found nowhere else in the Islamic world. Carpets commonly break with the tradition of abstract and continuous floral patterns, which are replaced with superb pictorial representations, monumental expressions of miniature paintings. There is little doubt that the pictorial rug which was first developed in Safavid Iran blossomed into a fully developed art in Moghul India.

Indo-Persian woolen pile carpet. Early 17th century. Detail.

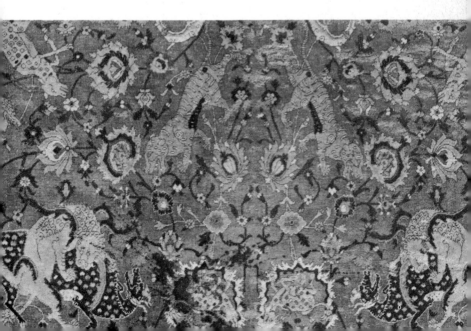

8 PALACES, MOSQUES AND TOMBS

The hand of Islam can be seen in all the arts not only the fine and the decorative, but also in the art of architecture. Throughout the world of Islam, the distinctive architecture is a visible stamp on the land of the presence not only of the religion but also the culture.

Apart from the mundane buildings of the people, there are three structures common to Islamic architecture, the mosque, the palace, and the tomb. Within the plan and confines of these, architectural features evolved which became common to all.

The mosque is unlike any other religious building in that it has no liturgical focal point except for the *mihrab* which indicates the direction of the Kaaba or Mecca and thus the direction for the faithful to face when praying. The mosque is, however, the focal point of the community acting not only as a religious centre, but also as club, town offices, hostel and even school. It has no furniture as such except for the *mimbar* or pulpit, therefore the entire desire to express artistically the love and adoration of God was channelled into the basic shape of the building and its interior decoration (ceramics, mosaics and relief carvings) as well as some of its

The grand courtyard of the Masjid-i Jami at Isfahan, Iran. Perhaps the finest example of the four-ivan court mosque in existence. Built by the Seljuk ruler Malik Shah (1072 - 1092).

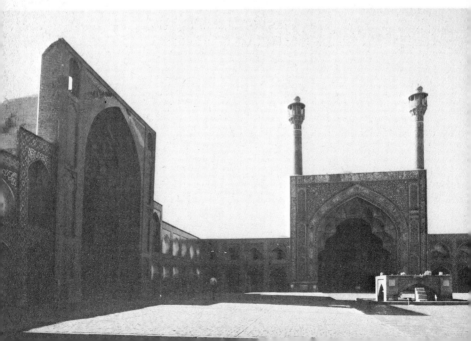

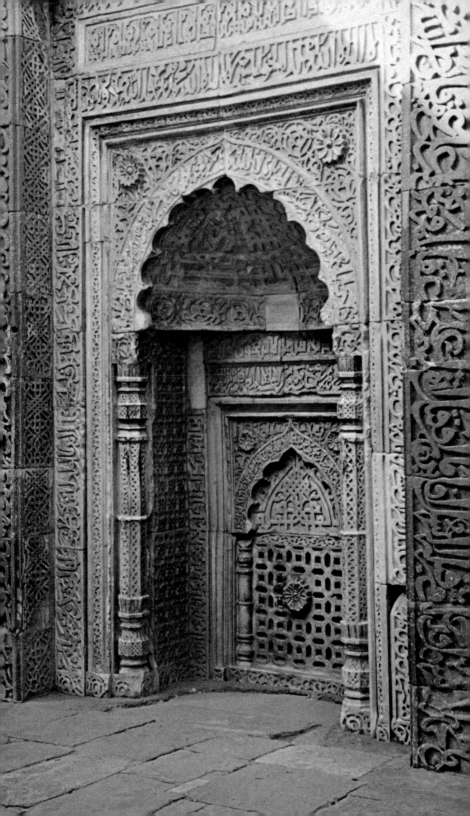

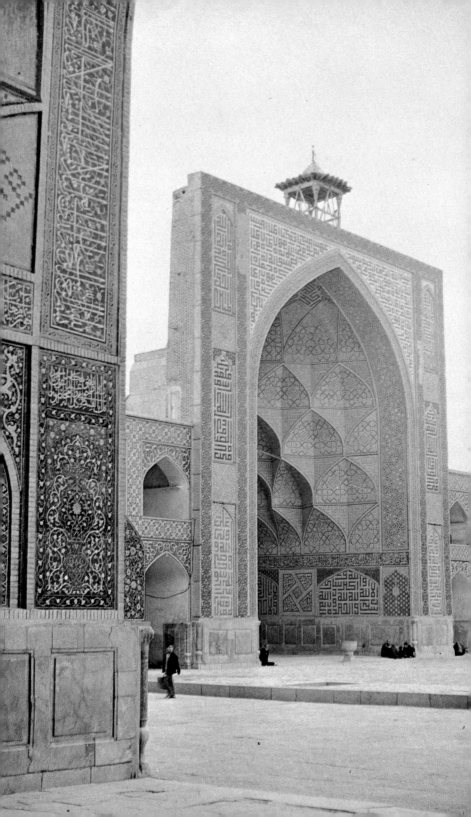

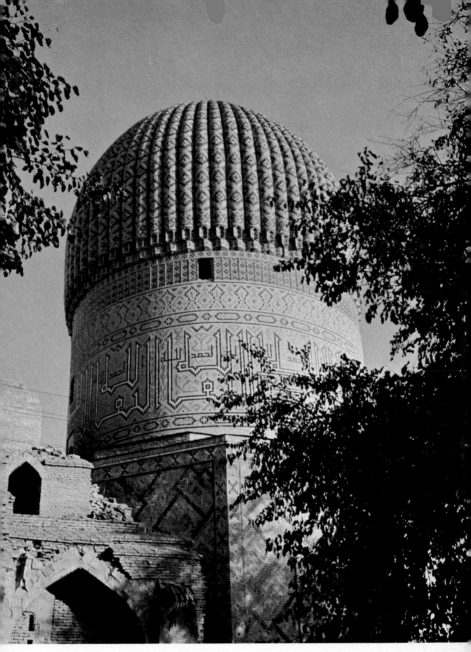

The exquisite dome and tile work of Timur's tomb, the Gur Emir at Samarkand
1434.

Left: The main court of the Masjid-i-
Jami, Isfahan, 1088.

Opposite overleaf: Superb sandstone
carving with inscription in Kufic on the
mihrab at the tomb of Altamish, at the
Quwat-ul-Islam complex, Delhi, 1253.

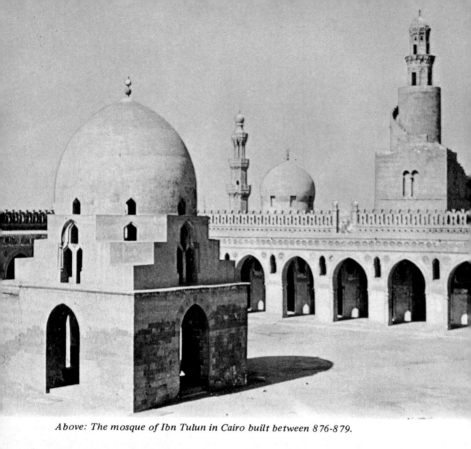

Above: The mosque of Ibn Tulun in Cairo built between 876-879.

Below: Pavilion in the Moghul Shalimar gardens at Kashmir, India. Early 17th century.

minor fittings such as lamps (in glass and metal) and rugs and carpets. Figurative decoration was not employed on the interior or exterior decoration of mosques, its place being taken by elaborate calligraphic quotations from the Koran, and naturalistic and abstract geometric designs and arabesques in an infinite pattern. It was the Islamic concept of the infinite idea of pattern and the universal equality of value placed on every element, that established a unity of style that was expressed in every Islamic country in all periods. In simple terms it can be seen in the growth, transformation, disintegration and reintegration of the design, ad infinitum. It is a transcendental art which found expression on objects no matter how small or large. Thus the ideals of Islamic art can be seen equally on a pottery plate from Persia, the mihrab in the Great Mosque of Cordoba in Spain, the superb marble tracery of the Taj Mahal in India or the brilliant enamel decoration of a glass mosque lamp from Mamluk Egypt. In architecture, the transcendental nature of matter is suggested by the ever changing space created by domes, arches, and hall or aisles. Space within and space without. It could be expressed equally in a garden especially the tomb garden of Moghul India and the pleasure gardens of Kashmir. The buildings themselves define the space around them, suggesting its infinite nature. Islamic architec-

Tile decorated in relief and painted in lustre and blue. From the mosque at Meshed. Persian (Kashan) early 13th century.

ture is a philosophic expression of the religion and yet in itself is not purely religious.

The mosque is perhaps the best embodiment of this idea which can be seen in all three types, the open plan, the four-*ivan* (aisles) and the domed.

The earliest form of mosque was the open plan which followed the layout first used by Muhammad at Medina. It consists of a rectangle with a wall or structure containing a *mihrab* on the side which faced in the direction of Mecca. In the early days, the *mihrab* was simply marked by a sign, but later, it took the now normal form a niche or alcove.

The open plan mosque became popular throughout the Islamic territories of the Mediterranian. The Great Mosque of Damascus

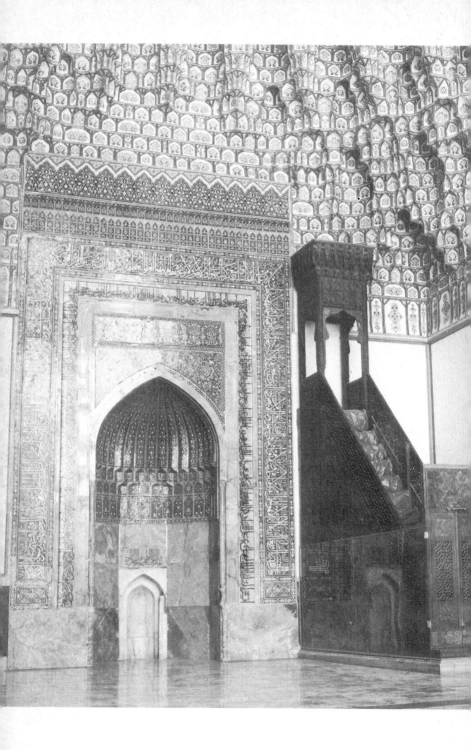

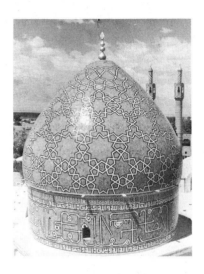

Above: The superb tiled dome of Shah Nematolah Vali, Kerman, Iran. Left: The focal point of a mosque, the Mihrab alcove indicating the direction of Mecca and the Mimbar, pulpit. Masjid-i Gohar Shad, Meshed, Iran.

The Great Mosque of Samarra built during the Abbasid caliphate also follows the open plan, and is the largest of all mosques. It is surrounded on all sides by a high wall within which are set towers. Its most distinctive feature is its unusual 27.43 metres high winding minaret.

Another mosque of similar plan with an unusual minaret is the Mosque of Qairawan which dates to about the 9th century. A notable feature of the building is its superb carved marble *mihrab* which is faced with lustre tiles.

The same open plan can be seen in Cordoba in Spain, in the Great Mosque. In a similar manner to the Great Mosque at Qairawan, which has seventeen aisles running towards the *mihrab* wall at right angles, the mosque at Cordoba originally had eleven aisles but later additions increased this to nineteen. The original building, begun in 785 did not have arcades surrounding the courtyard or a minaret, these were added at the same time as the aisles. The present *mihrab* was added by Al-Hakam II between 961-965. It is exquisitely decorated with mosaics, calligraphy and arabesques. Perhaps the most unusual feature of the mosque is the high roof of the aisles which is supported by double arches, one on top of the other.

The open plan was also followed in Egypt, one of the first examples of which is the Mosque of Al Hakim built during the Fatimid

built in approximately 705-715 A.D. during the Umayyad caliphate follows this plan. It has roofed aisles or arcades along three sides with the fourth side occupied by a prayer hall containing the *mihrab*. At the corners of the rectangle are minarets, the first used in Islam. The minaret became an important feature of the mosque in that it was used by the *meuzzin* to call the faithful to prayer. The dome of the present structure is modern, though there are indications of an earlier dome on the building.

135

period (969-1171). It follows a
pattern which reflects Abbasid
influence, also seen in the Mosque
of Ibn Tulun built between 876-
879. The façade of the building is
beautifully carved with geometric
patterns and calligraphy. It pre-
dates the super stone façade of
the Mosque of Al-Akmar which
was completed in 1125.

In Iran, mosques with four
open vaulted halls or *ivan* were
favoured probably due to the in-
fluence of the massive pre-Islamic
Sassanian *ivan* at Ctesiphon, built
by Taq-i-Kisra in the 3rd century.
The *ivan* or *iwan* is basically a
vaulted hall open on one narrow

Above: The Blue Mosque, Tabriz, Iran built in 1465. Although domed it does not have the four-ivan court. Below: The Masjid-i Jami, Veramin, Iran.

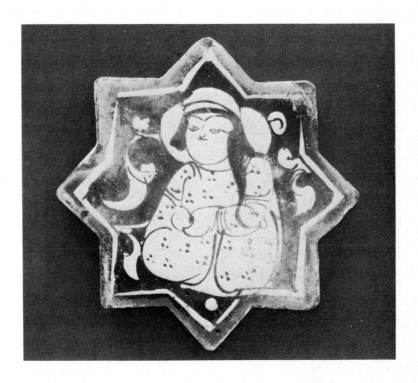

Lustre star tile, made at Rayy about 1200. Tiles such as this were used extensively in the interior decoration of buildings.

side. The most famous of the *ivan* mosques is the Masjid-i Jami, the Great Mosque of Isfahan built between 1072 and 1092 in Seljuk times. This magnificent building has the four *ivans* opening off the central court, each of which is joined to the other by arcades, around the central court. The huge dome 19.4 metres in diameter erected over the *mihrab* chamber is a masterpiece of architecture, resting as it does on trilobed squinches themselves on cylindrical piers. The smaller dome at the northern end of the mosque, directly opposite the large dome, is, perhaps, more interesting as it is mathematically the most perfect dome known. Although not part of the basic four *ivan* mosque plan, it is nevertheless aesthetically very pleasing. The Gunbad-i Kharka as it is known,

137

was built in 1088. There have been many additions to the building, made over a period of about a thousand years. The super tiled interior and exterior, a feature of Persian architecture, place it amongst the most beautiful mosques. It is certainly a masterpiece of Islamic architecture. Mosques of the four *ivan* type were constructed all over Persia and also penetrated into India.

Domed mosques are mainly associated with Turkey, the earliest example of which is the Mosque of Talkatan Baba near Merv which dates to the end of the 11th century. The domed mosque, which is rectangular in shape, draws together the entire structure under a central dome. There were variations on the theme and there were many unsuccessful attempts at creating such a structure, the architects resorting to the use of multiple small domes to cover the area. Two of the finest domed mosques

Right: The Selimiye mosque, Edirne, Turkey (1567 - 1575). Designed by the Turkish architect Sinan it is the finest example of a domed mosque.

Below: The Al-Azhar Mosque, Egypt, originally founded in 970 but since then a number of additions have been made.

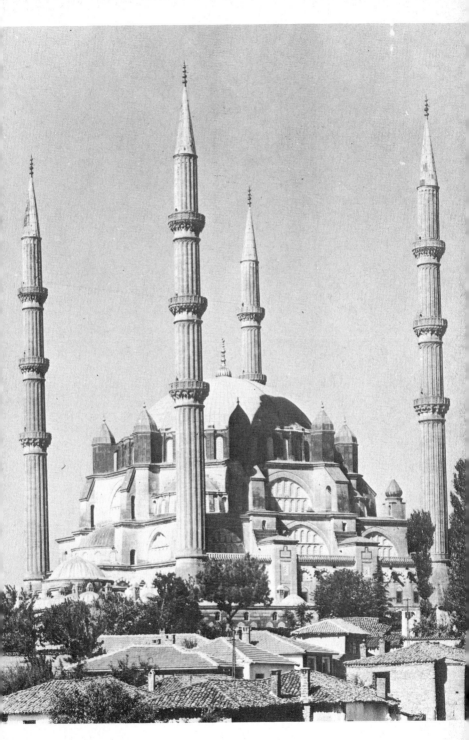

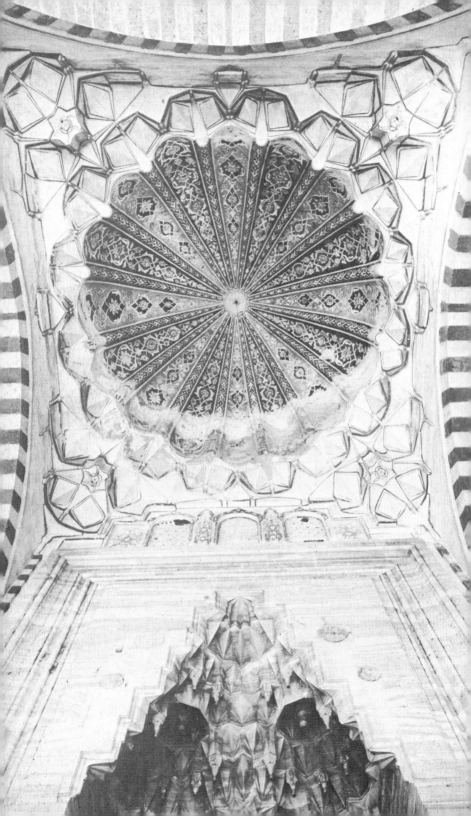

Right: The interior of the Sultani Ahmet mosque, Istanbul. (1609 - 16).

Left: The internal dome and interior decoration of the Selimye mosque, Edirne, Turkey.

Below: The Sultan Ahmet mosque, Istanbul, Turkey. The mosque has six minarets, one at each corner and two at the end of the forecourt.

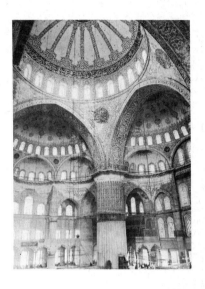

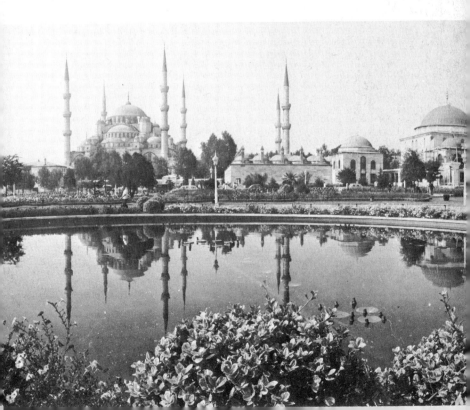

are the Uch Sherefli Mosque at Edirne, built in the early 15th century, and the Selimiye Mosque also of Edirne, built a little over a century later.

Another kind of mosque is peculiar to Kashmir in India, which was converted to Islam in the 14th century. It is a cellular prayer hall surmounted by a spire, a survival of an earlier Buddhist/ Hindu architectural tradition. The same unusual spires are also used on the top of the four *ivans* of the Masjid-i Jami at Srinagar, first erected in the 15th century and later rebuilt by the Moghul Emperor Aurangzeb.

The palace was the secular expression of Islamic art. Its structure was centred around the grand audience chamber of the ruler. By their very nature, their plan and features vary with the period and geographical location.

The Qutb Minar, the giant minaret built in 1199 in the Qawwat al-Islam mosque complex, Delhi, India.

Figurative decoration so conspicuous by its absence on the religious buildings is occasionally seen on wall paintings and sculpture which decorated the palaces. One of the largest of the early palaces was built by the Abbasids at Samarra near Baghdad. It had numerous rooms, apartments, a domed throne room and grounds with fountains and a canal. The Samarra palace which was made of unbaked brick has not survived, but a stone built palace dating to the late 8th century was constructed at Ukhaydir which still survives. Needless to say, palaces were constructed in various parts of the Islamic world, to suit local needs. One of the largest surviving is the Topkapi Saray in Turkey, which was started in the 15th century and continued to be added to until the 19th century. Its massive complex includes numerous pavilions, small palaces and secondary buildings set within beautiful gardens. One of the most beautiful palaces is at the Alhambra in Spain, constructed during the early 14th century by Yusuf I and his son Muhammad V, Nasrid rulers of Granada.

When considering the palaces of the world of Islam, the superb palaces of the Moghuls in India, especially the Red Forts of Delhi and Agra and the emperor Akbar's palace complex at Fatipur Sikri, should not be overlooked. They are masterpieces in red sandstone and white marble combining the architectural principles of Persia and of India. Mention must also be made of the superb pleasure gardens of Moghul India, in particular the Shalimar and Nishat gardens of Kashmir, created by the emperor Jehangir and his son Shah Jehan. These gardens serve not only as pleasure centres but also as palaces when the emperor visited his province. The Moghuls carrying on the tradition of the Timurids, who loved to live outdoors in luxurious tents.

The unusual pointed spire typical of the mosques of Kashmir. This one crowns the Shah Hamadan mosque at Srinagar, India.

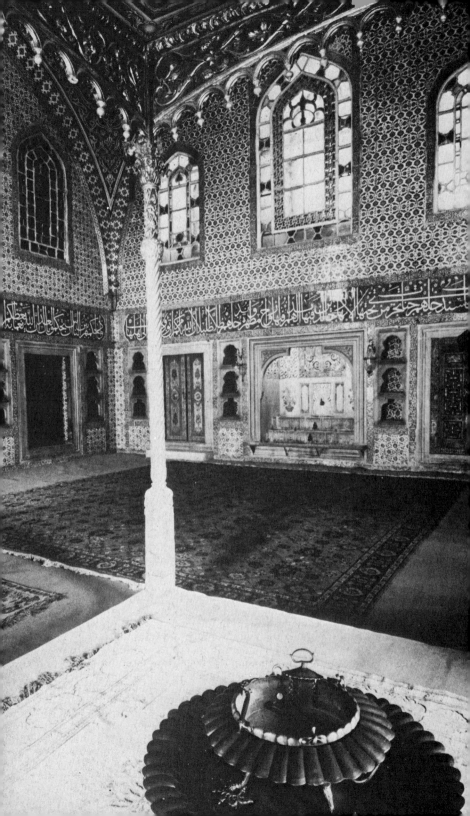

Left: The sumptuous interior of the Topkapi Suray Palace, Istanbul.

Below: The Panch Mahal, Fatehpur Sikri, built in 1569 - 1572 by the Moghul emperor Akbar. The architecture is an unusual marriage between Hindu and Islamic traditions.

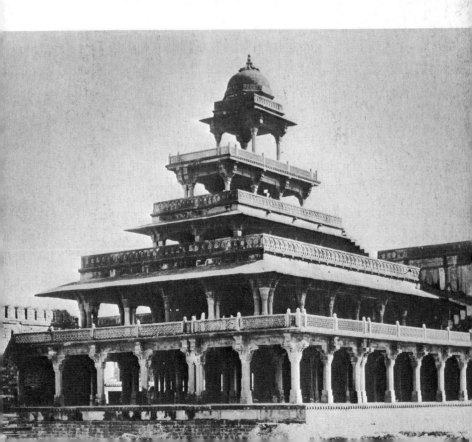

The mausoleum of Sultan Muhammad Oljetu Khudabanda. Sultaniya, Iran, (1307 - 1313). Probably the finest example of Mongol architecture.

The last of the three distinctive structures of Islam are the tombs and mausoleums. It is strange for a religion that discouraged the erection of opulent and elaborate tombs for the mausoleum to become such a distinctive part of Islamic heritage. The mausoleum was more a symbol of political might than of religious necessity. The typical plan, of which there were numerous variations, consisted of a chamber over which a dome was erected. The development of the lower structure and the shape of the dome is due to both geographical location and period. Some of the finest and most distinctive tombs include the 10th century tomb of the Samanids at Bukhara and Timur's tomb at Samarkand, Timur originally erected the tomb for his nephew but as he died before it was completed he was also interred there. The superb fluted blue faience dome is supported on a circular drum set on an octagonal base. The exterior is covered with superb geometric inscriptions in geometric Kufic while the internal

chamber is decorated with semi-precious stones. The mausoleum of Oljetu built at Sultaniya one of the Mongol capitals of Iran has a massive dome resting on an octagonal base upon which at the apex of each angle originally stood a minaret.

There is also another kind of tomb that consisted of a tower with a pointed tent roof. The largest of these, the Gunbad-i Qabus was built in the early 11th century by the ruler of Gurgan near the shore of the Caspian Sea.

Without doubt the finest and most magnificient mausoleum and one of the greatest treasures of Islam is that masterpiece in marble, the Taj Mahal at Agra, in India. This superb structure exquisitely constructed of white marble is the very epitome of

Above: The interior of Humayan's mausoleum,
Below: Humayan's tomb, Delhi, completed in 1572.

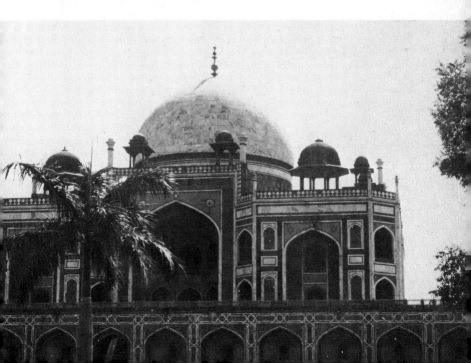

Detail of marble relief carving on the exterior of the Taj Mahal, Agra.

perfection in Islamic architecture. It combines the traditions of Persia with those of India. It is a combination of the work of the mason, the jeweller and the calligrapher. A beautiful marble lattice work screen surrounds the false tombs of Shah Jehan and his wife Mumtaz Mahal (the real tombs are in a vault immediately below). The walls are worked in pietra dura with semi precious stones, while outside there are superb white marble reliefs and calligraphy inlaid in black marble. Shah Jehan had originally intended to build a duplicate in black marble but was dethroned and imprisoned by his son Aurangzeb before the work could begin.

The story of Islamic architecture is so vast and complex that it is not possible to do it justice in a book of this size. Islamic architecture, however, speaks for itself, its beauty and magnificence has only to be seen to be appreciated. It is a living expression of a living and vibrant religion.

Perhaps the most famous building in the world - the Taj Mahal at Agra, India.

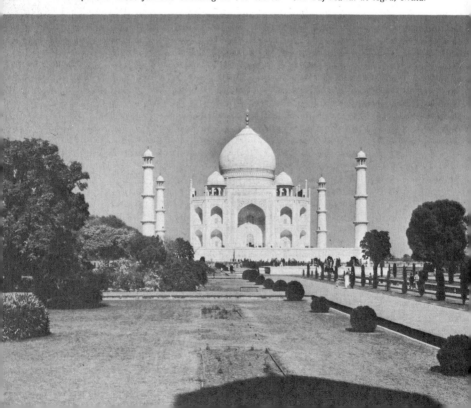

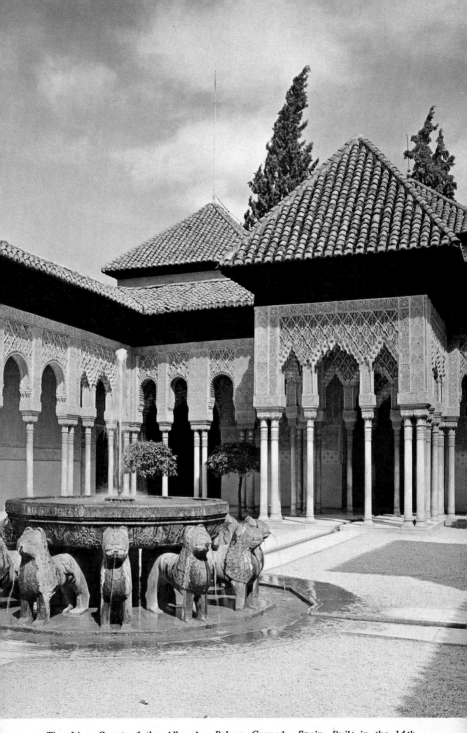

*The Lion Court of the Alhambra Palace, Granada, Spain. Built in the 14th
century by the Nasrid rulers of Spain. The Court was the centre of the harim area.*

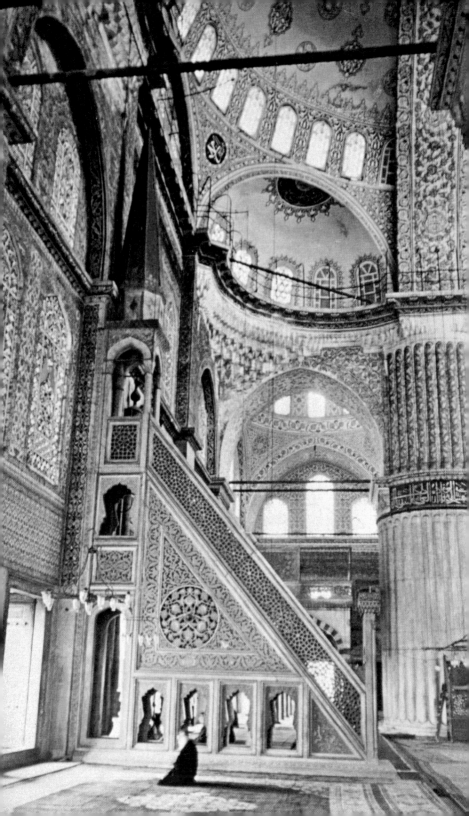

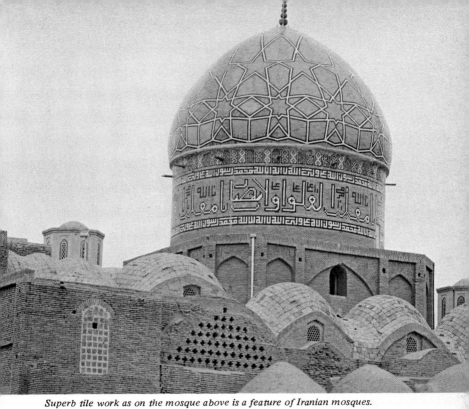

Superb tile work as on the mosque above is a feature of Iranian mosques.

Left: The interior of the mosque of Sultan Ahmed, Istanbul, Turkey, built in the early 17th century and popularly known as the Blue Mosque.

Below: The courtyard of the Masjid-i-Jami, Srinagar, Kashmir. Note the unusual spire in contrast to the usual Islamic domes as illustrated above.

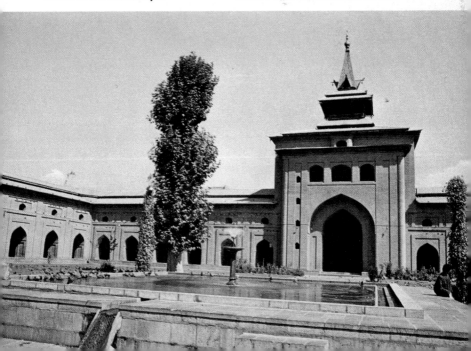

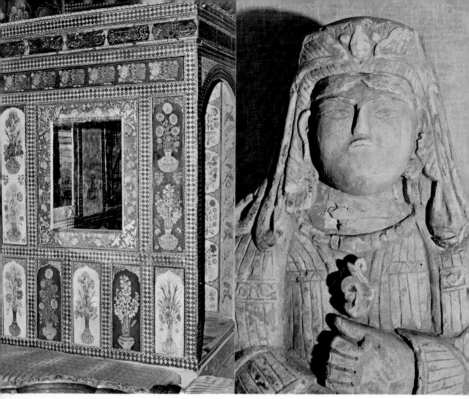

Part of the exotic interior decoration of Topkapi Palace, Istanbul.

Sculpture in the round is unusual in Islamic art. The above stucco figure of a prince or king was made in Persia in the 13th century.

The most famous Islamic building in the world, the Taj Mahal at Agra, India, built by the emperor Shah Jehan about 1635.

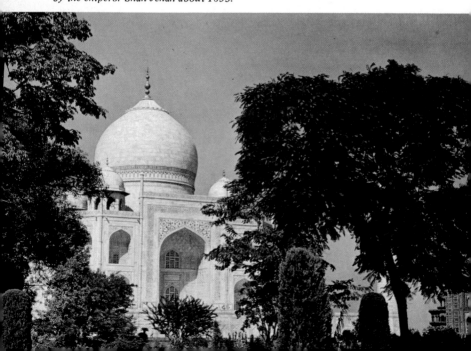

9 IVORY, JADE, CRYSTAL AND JEWELS

The majority of the Treasures of Islam fall into one of the categories dealt with in the foregoing chapters. However, the minor arts also occasionally produced great masterpieces especially in ivory, hardstones such as rock crystal and jade, and jewellery.

The superb ivory oliphants or drinking horns made in Mesopotamia during the 10th to 12th centuries can be ranked amongst the finest examples of Islamic art. The motifs are similar to those found in paintings at Samarra and the sculptures of Achthamar. Animal figures within roundels of tendrils usually cover the majority of the wide central

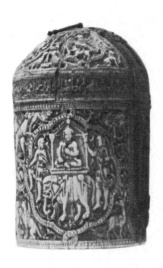

Above: Spanish ivory casket inscribed in Kufic, made at Cordoba c.969. Left: Ivory oliphant or drinking horn. Mesopotamia 11th century. Below: Superb example of a Spanish ivory casket with figurative and animal decoration.

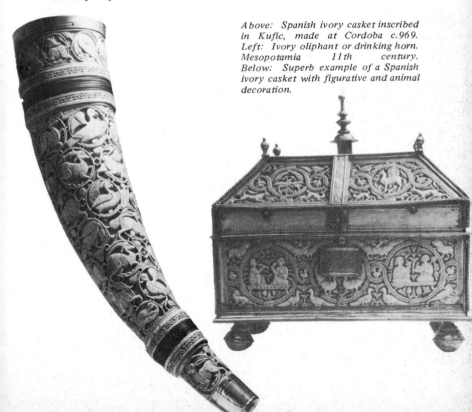

decorative band, while narrow bands of animal and geometric vegetative motifs surround the tip and base. The oliphants were only part of a local craft of ivory carving.

The figurative tradition of Mesopotamia was inherited by the Fatimids who developed it to such an extent that its excellence probably surpasses all others. Fatimid art is often looked upon as the most beautiful in all Islam. It is perhaps best expressed in the superb metalwork and ivory, the latter which is unparalleled. Superb carvings were produced under the Fatimids who carried on the artistic traditions of the Abbasids, employed by their predecessors the Tulunids. To the figurative motifs of this tradition was added a decorative tradition based on an infinite linear abstract ideal of geometric expression. The linear designs which are superimposed one on the other create an infinite geometric design of polygons, triangles, stars, etc. The two elements of Islamic art, the figurative and the infinite abstract, were both used side by side.

In Spain, magnificent works in

Jade drinking vessel carved in the form of a shell or gourd with a curved handle terminating in the head of an ibex. Made for the emperor Shah Jehan, and engraved with his title. India, Moghul 1657.

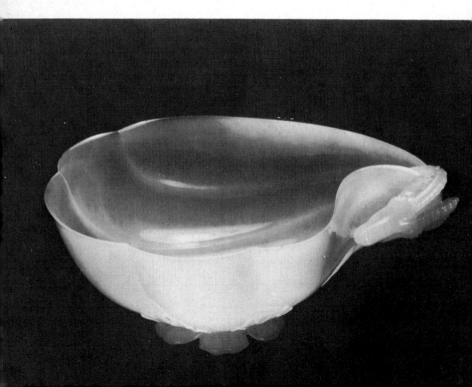

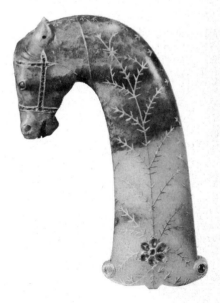

Nephrite cup. East Persian, late 15th century.

ivory were produced under the Umayyads. The style is similar to that of the Fatimids, but incorporates distinctive Spanish elements. A popular object made during this period was the casket, both circular and rectangular, the entire surface of which was covered with exquisite carving. Interlaced floral, animal and figurative designs combined with calligraphy carved in high relief were popular.

Sicily also produced carvings of similar type which are often difficult to separate from the Spanish. The Sicilian examples, however, can sometimes be distinguished by the local feature of low relief carving which occasionally has been part painted. Hunting scenes were popular and the animal designs of a somewhat Sassanian nature suggest Persian influence. Ivories continued to be made in Spain during the 14th and 15th centuries, but the designs tend to lack the early inspiration and vigour.

The art of jade carving seems to have been particularly popular in Timurid Persia. Although there are few surviving examples which date prior to the 15th century, it is evident that the art was based on an earlier tradition, probably influenced originally from China. The quality of the jade was emphasised by the simplicity and restraint of the carving.

The Timurids' love of jade was continued by their descendants, the Moghul emperors of India, under whom magnificent examples were carved. Jade is a very hard substance and cannot be "carved" in the literal sense of the word. With a hardness of six and a half on the Mohns scale (soapstone has a hardness of one degree), it has to be worn into shape by abrasive harder than itself, which means substances

Jade sword handle in the form of a horses head, inlaid with gold and set with precious stones. Moghul 18th century.

155

such as crushed garnets or corundum, diamond etc. It requires great skill, a skill which the Moghul used brilliantly. The shapes of the vessels often imitated flowers and fruit and as with Timurid jades, simplicity and restraint are paramount. Carving, when present is deep, but on the whole sparse, attention being paid principally to the contours of the vessel. Many of the pieces are encrusted with jewels, which suggest the hand of the jeweller, rather than the artist.

Jewellery has of course played an important part in the Islamic world, especially within court circles. The jewellers often combined the arts of metalwork in gold and silver with the lapidary. Fine jewellery was made under all dynasties especially the Fatimid's under whom it was made in great quantities, probably a reflection of the richness of court life.

The Fatimid excellence of carving can also be seen in mag-
nificent works in rock crystal. The art was probably first developed under their predecessors the Tulunids. Fine ewers and beakers were exquisitely carved with bold figurative motifs of animals, birds and arabesques. Some vessels were also inscribed with the name of their owner or with verses from the Koran. Fatimid rock crystal was admired throughout the Islamic world, so much so that glass imitations were later made in Iran. The tradition was sufficiently strong to stimulate artists in Moghul India to use the same material.

The artistry and inspiration of Islam showed itself in many ways. In leather, superb treasures of leather filigree work were lavished on book bindings, while exquisite lacquer paintings were executed in Persia. Throughout the world of Islam, in all periods, the culture and traditions of the religion stimulated artists to excel themselves in enriching the world with the treasures of Islam.

Painted leather panel. Persian, mid 19th century.

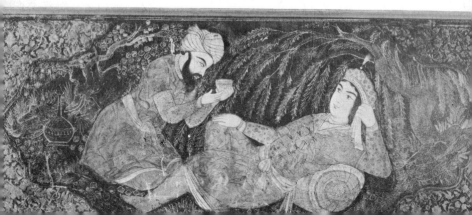

CHRONOLOGY

622 — Hijra
632 — Death of Muhammad
632-661 — Orthodox Caliphs, ARABIA
638-640 — Arab Conquest of PERSIA
641 — Conquest of EGYPT
641-868 — EGYPT governed by Umayyad & Abbasid Governors
661-750 — Umayyad Caliphs, DAMASCUS
661-820 — PERSIA governed by Umayyad & Abbasid Governors
669-800 — N. AFRICA governed by Umayyad & Abbasid Governors
710-712 — Arab conquest of SPAIN
711 — Arab conquest of SIND
713-750 SPAIN governed by Umayyads of Damascus
750-1258 — Abbasid caliphate, capitals at BAGHDAD & SAMARRA
756-1031 — Umayyads of CORDOBA
868-904 — Tulunids, EGYPT
874-999 — Samanids, PERSIA
900-972 — Fatimids, N. AFRICA
969-1171 — Fatimids, EGYPT
1037-1157 — Seljuks, PERSIA & MESOPOTAMIA
1077-1300 — Seljuks of Rum, TURKEY
1168-1250 — Ayyubids, EGYPT
1206-1349 — Ilkhanids, PERSIA
1206-1287 — Slave Kings, INDIA
1252-1517 — Mamluks, EGYPT
1300-1924 — Ottomans, TURKEY
1320-1412 — Tughlaks, INDIA
1369-1502 — Timurids, PERSIA
1414-1443 — Sayyids, INDIA
1451-1519 — Lodis, INDIA
1502-1736 — Safavids, PERSIA
1517-1805 — Ottomans in EGYPT
1526-1857 — Moghul Emperors, INDIA

INDEX

Acknowledgments *The publishers gratefully acknowledge the following for permission to reproduce illustrations: The British Museum; The British Library; Christie, Manson and Woods Ltd.; Egypt Air; Government of India Tourist Office; Mr. J. Hunt; Ministry of Tourism, Egypt; Novosti Press Agency; M.R. and J.D. Ridley; Royal Iranian Tourist Office; Sotheby & Co.; Spanish National Tourist Office; Turkish Tourism and Information Office; The Victoria and Albert Museum. A number of illustrations were specially taken for the book by David Couling.*